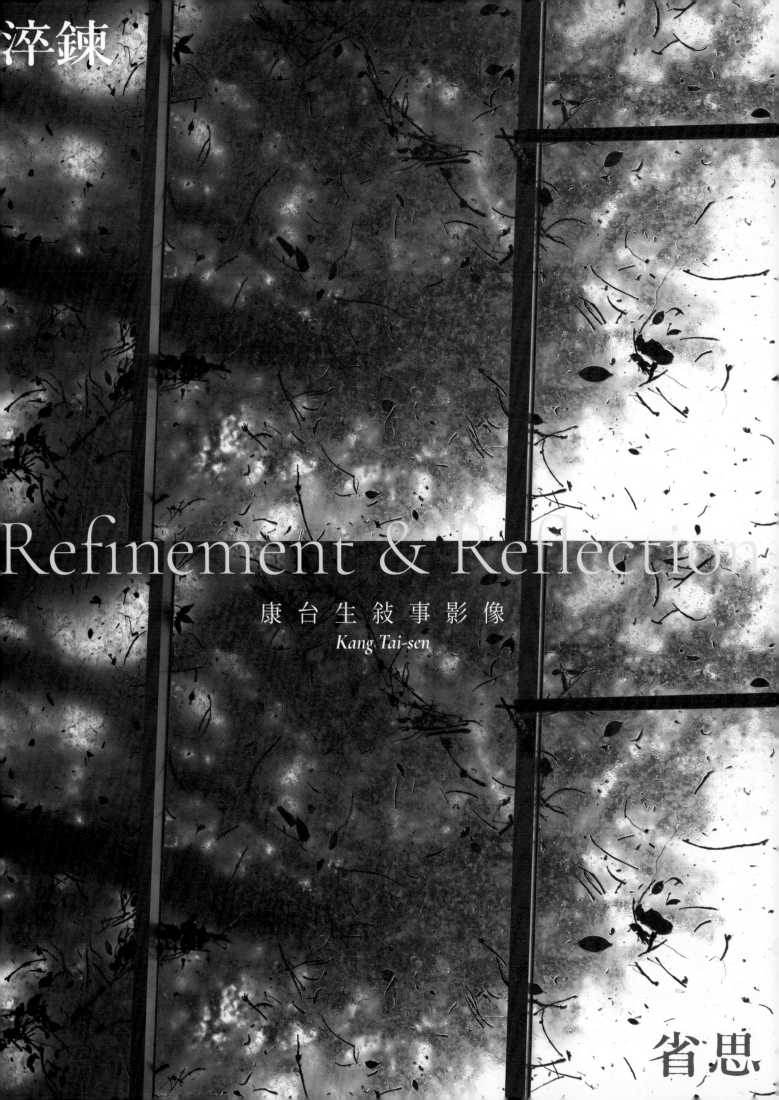

淬鍊

Refinement & Reflection

康 台 生 敍 事 影 像

Kang Tai-sen

省思

序文

文化部部長
Minister of Culture

李永得
Lee Yung-te

藝術創作無法隔絕於社會脈動之外,攝影具有快速銳利的寫實力與文化社會敍事性,也更容易去關懷社會與見證歷史。康台生教授在教育界深耕四十多年,厚實了臺灣攝影藝術教育的沃土,同時淬鍊出深厚又多元的藝術表現形式,是受人敬重的教育工作者,也是一位成就卓越的藝術家。

康教授 1951 年出生於臺灣嘉義,國立臺灣師範大學美術研究所碩士,歷任臺師大藝術學院院長、設計研究所所長,現任中華攝影藝術交流學會名譽理事長,曾擔任澳洲昆士蘭科技大學、中國平遙國際攝影節、臺北國際攝影節等大型活動暨展覽策展人。康教授將學術環境的任務和挑戰,視為建構創作學理的磐石與實現理念的動力,發展出獨特的影像敍事美學;熱愛旅遊的他有許多作品呈現臺灣生活週遭環境,即使是尋常的風景,透過攝影鏡頭記錄下來的瞬間,也能發現其中獨特的意涵。

文化部所屬國立國父紀念館本次於中山國家畫廊舉辦《淬鍊・省思——康台生敍事影像》攝影展,以藝術名人堂概念,展出康教授創作生涯至今的代表作品,歡迎社會大眾前往參觀,分享攝影藝術自由獨特的敍事表現,共同探索生活的共鳴與感動。

Art creation can't be isolated from the pulses of society. With the fast and sharp realistic style and cultural and social narrativity, photography can care about the society and witness history more easily. Prof. Kang Tai-sen has been dedicated to education for more than forty years, consolidating the fundaments of photography and art education in Taiwan, also refining art expressions into solid yet diverse works. He is both a respectable educator and an artist with outstanding achievements.

Prof. Kang Tai-sen was born in Chiayi, Taiwan, in 1951. He received his MA degree at the Department of Fine Arts, National Taiwan Normal University. Used to serve as Dean of the College of Arts and Director of the Graduate School of Design, NTNU, he is the Honorary Chairman of the Chinese Society of Photographic Art Exchange at present. He was also the exhibition curator of large events including Queensland University of Technology, Pingyao International Photography Festival, and Taipei International Photography Festival. Not only does Prof. Kang regard the missions and challenges in the academic environment as the cornerstone to construct creative theories, but also the energy to practice concepts and develop unique aesthetics of image narrative. As a travel lover, he presents the living surroundings of Taiwan in many of his works. Unique meanings can be found in ordinary scenes through the moments recorded by a camera lens.

National Dr. Sun Yat-sen Memorial Hall, Ministry of Culture, will hold "Refinement & Reflection" and exhibit Prof. Kang's representative works in his creative career to date in the form of the hall of art. I welcome the public to visit the exhibition, share the free and unique expression of photography, and explore the resonance and touching moments in life together.

沉鍊 · 省思

序文

國立國父紀念館館長
Director-general of National Dr. Sun Yat-sen Memorial Hall

王蘭生
Wang Lan-sheng

康台生教授 1951 年出生於臺灣嘉義，歷任國立臺灣師範大學藝術學院院長、設計研究所所長、輔仁大學藝術學院院長，不僅是資深藝術教育工作者，多年的教學生涯，也建構了深厚創作學理基礎；長期不斷地創作與發表，以大量的攝影作品關懷社會，撫慰心靈、提供希望，引起觀眾的視覺認同與共鳴。

投入攝影創作四十多年，康台生教授至今共舉辦十七次個展，並應邀國內外各大美展、國際攝影節等展出新作。康教授喜歡敘事表現手法，他有些貌不驚人的攝影作品，是對場景真實的記錄，隨著時間的流逝，過往的真實成為記憶，轉瞬即逝的現象藉由攝影成為永恆，也見證了歷史。

本館中山國家畫廊很高興邀請康教授舉辦個展，本次以《淬鍊・省思》為題的攝影展，規劃四個單元：《虛實映像》、《花情》、《城市定格》、《生活符碼》，包括早期作品和近年尚未發表的新作，有主題涵蓋三十年以上的持續創作，也有許多張手機拍攝、訴求生活化的隨興與臨場感的作品；同時搭配以系列、組合編排方式來說故事，以攝影觀察一個城市的生活情境與氛圍，透過豐富的色彩層次和巧妙的構圖，烘托出戲劇張力與城市印象，同時傳達內心溫暖的感受和詼諧的巧思，歡迎所有喜愛攝影的朋友蒞臨觀賞。

Prof. Kang Tai-sen was born in Chiayi, Taiwan, in 1951. Former Dean of the College of Arts, Director of the Graduate School of Design at NTNU, and Dean of the College of Art at Fu Jen Catholic University. Not only is he a senior art educator who has constructed a solid foundation of creative theories in the years of his teaching career, but he also has been creating and publishing new works continuously. Showing concern for society, soothing minds, giving hope, and arousing visual recognition and resonance through a large number of his photography works.

Dedicated to photography creation for more than forty years, Prof. Kang Tai-sen has held seventeen solo exhibitions to date. He was also invited to display his latest works in domestic exhibitions and international photography festivals. Prof. Kang likes the narrative techniques. Some of his photography works that look ordinary are truthful records of scenes. With time, the past reality becomes a memory and the transient phenomenon turns into eternity through photography, which also witnesses history.

I'm glad that Chung-Shan National Gallery invited Prof. Kang to hold the exhibition. The photography exhibition with the topic of "Refinement & Reflection" is divided into four subjects: "Abstract and Concrete Impression," "Flower Love," "Freeze Frame of City," and "Life Code." The early works and the unpublished new works in recent years are included. His early works and unpublished new works in recent years are included, some topics cover the time frame of more than thirty years, and some works were taken with smartphones addressing casualness and authenticity in life. At the same time, the stories are told in series and in a combined arrangement. Photography is used to observe a city's life situation and its atmosphere. Rich colors and cleverly designed compositions highlight the dramatic tension and impression a city gives, also conveying warm feelings and ingenuity at the same time. I welcome all photography lovers to visit the exhibition.

淬鍊 · 省思

序文

郭英聲
Quo Ying-sheng

明明是現實的景況，卻處處透著一種超現實的氣味，停格的不僅是影像，更同時是鏡頭後面，攝影者的心。

古典的線條，城市的符號，花與身體，後現代都市情境……，攝影家康台生將《淬鍊‧省思》區分為《虛實映像》、《花情》、《城市定格》與《生活符碼》，在不同區塊的影像中，深邃著自我獨特美學觀的抒發。

看似偶遇，看似日常，看似平淡……，卻其實內斂著浮世百態的真實呼吸。

影像有時候很像是一面鏡子，攝影者將它定格之後，不同的人，從中看見不同的風景，或直觀或單純或繁複……，是紀實，也是心中所感受到的。我在康台生作品中所看見的，是混雜中所產生的生命力。

始終保持著一份自在，拍攝他眼睛所看見，心裡所感受到的，康台生在過程中淬鍊，也在時間中不斷不斷的省思。

Refinement & Reflection

A surreal feeling prevails in the real scenes. It is not only the scene that is captured but also the photographer's heart behind the lens.

The classical lines, codes of the city, flowers and bodies, postmodern city scenes......The photographer, Kang Tai-sen, divides "Refinement, Reflection" into "Abstract and Concrete Impression," "Flower Love," "Freeze Frame of City," and "Life Code" and expresses profound personal and unique aesthetics in the images of all series.

Looking like random encounters and daily life on the surface, these photography works are real breaths of vicissitudes of life.

Sometimes an image is like a mirror. After the photographer captures the moment, different people will see different scenes. Direct, simple, or complicated...... They record both the reality and the feeling in minds. What I see in Kang Tai-sen's works is the concoctions of vitality.

Always with a sense of freedom, he photographs what he sees and feels. He makes refinements in the process and makes reflections repeatedly in time.

浮鍊 · 省思

序文

秦偉
Chun Wai

《淬鍊‧省思》展示著康台生先生過去四十年在攝影創作路上的熱愛與堅持。

無論處身境內，走進亞洲鄰國，抑或是遠行到萬里以外的異鄉，他總愛一機隨身，以鏡頭去觸摸眼前的事物。環顧康先生的作品，所攝畫面時而隨心，時而精心佈局，圖片流露著作者對生命一份摯誠的喜悅，對一切偶遇的殷切。

在他的《生活符碼》和《城市定格》兩組作品中，照片漫射出一份隨心率性，就猶如作者本人對觀賞生活的寫照。作品沒有揪動人心的場面，不追求決定性的瞬間；在穿梭於東方與西方的大城小景中，作者拍下生命中的尋常，而《生活符碼》和《城市定格》就如片片絮語，向觀者訴說著他對城市生活的觀照，看似平淡的照片中，往往令人莞爾。

在東西方社會中，無數的「花」都會被賦予文化或宗教的意涵，折射著個體生命中的情和意。在《花情》系列中，作者運用色彩對比、線條和明暗差異去勾劃出個人獨有的「花」視角，透過設置事物的形象和圖形之間互相連動，像編寫一冊私密的「花語」。

真實和虛幻的互構在藝術領域中常被引用。在洪量的攝影圖像中，連接不同事物的形象可以有無盡的方案；當人物、敍事、時間和空間的界限經過藝術家重塑編織，由此而再現的影像方塊往往能引發讀者另類解讀。在《虛實映象》系列中，作者糅合黑白、彩色、刻意與偶遇的影像處理手法，呈現自身對外在世界的發現。

康生先一直不懈藝術教育工作，即使是退下崗位，他仍致力推動台灣與國際的影像交流，拓展攝影藝術走進社區。在他主持的 2018 台北國際攝影節中，展出的除了傳統本土藝術攝影，有更多是來自海內外，在形式、風格和內容表現迥異多元的當代影像作品；這趟豐盛的視覺盛宴展現出他對攝影抱有寬廣的視野和包容性。與他相交，給我一份中國傳統儒生謙謙君子的印象，溫文爾雅，思路開闊，亦不滯於藝術門派及偏見，儘管我們彼此在創作觀念上迂迴相悖，仍以廣闊的胸懷接納、珍惜。

就如康先生所言，《淬鍊‧省思》是他對個人七十歲暨創作四十載的省思，亦是他未來出發再創作的力量；對藝術家而言，自省、堅持，就是一份跨越自我的能量。

2022 年 2 月

"Refinement & Reflection" shows Mr. Kang Tai-sen's love and persistence in photography in the past forty years. Whether he stays in Taiwan or visits other Asian countries, or even travels to far away foreign lands, he always brings his camera and observes his surroundings through his lens. The photographed images of Mr. Kang's works are sometimes casually taken, sometimes carefully arranged. But both reveal the photographer's sincere joy towards life and aspiration for all encounters.

In the two series of works, "Life Code" and "Freeze Frame of City," the photos give forth a sense of freedom like the photographer's portrayal of his own life. Without the heart-wrenching scenes, the works don't pursue the decisive moment. Instead, the photographer takes the ordinary in life among ordinary scenes in eastern and western large cities. "Life Code" and "Freeze Frame of City" are just like the pieces of discourse telling the viewers his perspective about city life. The photos that are seemingly plain always make people smile.

In the eastern and western societies, numerous "flowers" will be endowed with cultural or religious meanings, reflecting love and feelings of individual life. In the series of "Flower Love," the photographer uses color contrast, lines, and brightness to sketch his personal and unique perspective on "flowers." The arrangement of the object's image and the interaction between the pictures are like writing a private booklet of "languages of flowers."

The mutual construction of concreteness and abstractness is frequently cited. In a sea of photographic images, there can be unlimited versions of images connecting with different things. After the boundaries between figures, narrations, time, and space are reshaped and woven by the artist, the reappearing image blocks tend to trigger the viewers' alternative interpretation. In the series of "Abstract and Concrete Impression," the photographer combines black and white, color, deliberate, and occurrences image processing techniques to present his personal findings of the outer world.

Mr. Kang has been engaged in art education. Even after leaving the post, he is still dedicated to the promotion of image exchange between Taiwan and the world and expanding photographic art to the community. The 2018 TAIPEI PHOTO directed by him exhibited not only the traditional local art photography but also the contemporary image works of the different and diverse forms, styles, and contents. The rich visual feast reveals his broad vision and tolerance for photography. During the encounters of me and him, he gives me the impression of a Chinese traditional scholar and modest gentleman, cultured and elegant with broad thoughts, not restricted to any art school or prejudice. Despite our contrary creative concepts, we still accept and cherish each other with a broad mind.

As Mr. Kang said, "Refinement & Reflection" is the reflection on his seventy years of life and forty years of creation as well as the energy for a new start and future creation. For an artist, self-reflection and persistence are the energy to surpass himself.

February, 2022

王川

Wang Chuan

Refinement & Reflection

今天，攝影幾乎包攬了我們的觀看，阻斷了我們與真實世界的直接關聯，甚至在潛移默化之中代替著我們的思考。這恐怕已是我們無力改變的現實。我們越來越確信，攝影是一個複雜的事物。這種複雜性來自諸多方面——基於科技發展、技術驅動的根本模式，以及由此而注定的動態前行；面對對象直接成像的基本原理，攝影圖像中的萬般皆有早已被大千世界鑄就；快速積累且不斷翻新的豐富語彙和表達方式，在與對象主題反覆疊加之後，生成了浩如煙海的影像世界；不可阻擋的擴張天性從未收斂，使我們幾乎無法找到與之毫無交集的領域。很多人認為這種複雜性是攝影始終面臨的問題，這沒錯。但我們也必須承認，攝影最為持久的魅力也恰恰棲身於此。

面對上述內容，絕大多數人是渾然不覺的。思考這些原本就不是體量巨大的攝影消費人群的任務。然而這又是一個我們根本無法忽略的存在，終究要有人予以關注，加以詳查，條分理析，以明世人。對這些人來說，這是他們給自己下達的任務，進而變成了他們工作生活的組成部分。這，是一種選擇，也是一種宿命。與台生先生相識交往多年，我深知，他就是這其中的一員。攝影與他的視野、思維，工作和生活，已難分割。只不過較之常人，他與攝影的關聯更加全方位。

遍覽台生先生作品，我有一種重走攝影之現代主義之路的感覺。那是一種對攝影語言永無止境的錘鍊和對美好事物的不懈追索。於我而言，攝影的現代主義階段，這個曾經被視為已被後現代主義所顛覆和終結的重要時期，正慢慢地展示出它作為攝影借以確立身份和門戶之關鍵階段的巨大價值和持久意義，恰恰就在當下。一直行走在這條路上的台生先生，於他的所見所思、所拍所攝中，仰觀生命之循環，於生老病死間體會天地陰陽，形潛像顯；俯查世間之微妙，向四季輪轉中記錄時光荏苒，歲月留痕。這條路上，他始終保持「淬鍊」的領悟與「省思」的清醒，他的作品讓我們得以感知他的自律與持守。當這種修行貫穿於他四十年勤勉不輟的從教生涯時，可以想見其為師者，必是身體力行，知行合一的典範。

我們與攝影到底建立起了什麼樣的關係？在這對關係中誰才是主宰？通過攝影我們還能做些什麼？在這個疊代迅疾的媒介面前我們何以自處？面對這些問題，康台生先生已用自己經年累月的思考與實踐，以及入眼入心的作品，給出了他自己的答案。

蒙台生先生之邀，特撰此文以抒心懷，不勝榮幸。

2022 年 3 月 12 日
於花家地中央美術學院

Today photography prevails in what we see every day, blocks our direct connection with the real world, and even replaces our thinking unconsciously. I'm afraid this is the reality we can't change. We are more and more convinced that photography is complex. Such complexity comes from many aspects based on technological development, the fundamental technology-driven model, and the predestined dynamic forward moving. With the basic principle that objects are turned into images directly, every image of photography has already been made in the colorful world. After the repeated interaction with objects and subjects, the rich lexicons and expressions accumulated rapidly and evolved endlessly to create the borderless world of images. As the expansion never stops, it is almost impossible for us to find a field that hasn't been affected. Many people believe such complexity to be the issue photography will have to deal with. It may be true, but we still have to admit that it's also where the endurable charm of photography lies.

Most people have never thought about the issue mentioned above. It is indeed not the mission to think about for a huge number of photography consumers. However, this is an existence that we can't ignore. After all, they should be paid attention to by people, and make investigations, and analyses, and make it clear to the world. For them, this is the mission they give to themselves and further becomes the composition of their work and life. This is a choice, but also his destiny. As a friend of Mr. Kang for years, I deeply know that he is one of them. His vision, thinking, work, and life can't be separated from photography, and his connection with photography is comprehensive compared with common people.

Taking an overall look at Mr. Kang's works, I have the feeling of looking back on the modernist process of photography. That is the endless refinement of the language of photography and the unremitting pursuit of beautiful things. For me, the modernist stage of photography, the important period which was believed to be subverted and terminated by post-modernism, is slowly showing its huge value and lasting meaning as the critical stage for photography to establish its identity and status right now. Mr. Kang has always stayed on this path. What he sees, thinks, and takes reflects the circle of life. He experiences birth, aging, sickness, and death as well as heaven and earth in the patent and latent images, observes the subtlety of the world, records the passage of time in the turning of seasons, and leaves marks in the time frame of life. On the way on this journey, he always keeps the understanding of "refinement" and awakening of "reflection." His works enable us to perceive his self-discipline and persistence. As cultivation is practiced diligently throughout his forty-year teaching career, he is a model of putting the knowledge into practice.

What relationship have we built with photography? What is the dominator in this relationship? What else can we do through photography? How do we settle down in front of the medium of repeated and rapid operation? In the face of these questions, Mr. Kang has given his own answers with his years of thinking and practice and intriguing works.

Under the invitation of Mr. Kang, it's my honor to write this article to express my mind.

Wang Chuan at Central Academy of Fine Arts, Hua Jia Di, on March 12, 2022

自序

康台生

Kang Tai-sen

Refinement & Reflection

「藝術創作對我而言是生活的淬鍊和省思。」

藝術創作與活動，無法隔絕於整個社會的脈動之外，藝術創作的動力來自於人類對美好事物與生活的需求，而藉由藝術活動來滿足撫慰心靈，提供希望與能量，使藝術創作益顯得具有價值與意義。攝影的特質，具有快速銳利的寫實力與文化社會敘事性；攝影的媒材，適合傳達與記錄真實的生活。如果能善用這些特質，能夠引起視覺認同與共鳴，也更容易去關懷社會與見證歷史。

景物隨著四季晨昏變幻，植物也有「生、老、病、死」的生命的循環，拍攝作品的當下，是對場景真實的記錄，隨著時間的流逝，物換星移，當初的真實變成虛幻，成為記憶；但是，作品本身的敘事性和對攝影者的意義，卻是恆久不變的。

我喜歡敘事表現手法，「敘事」這個系列作品，前後已經持續拍攝四十年以上。當初只為單純地捕捉「生命」或「生活」的感覺，在創作心態上保持「自在」，期能讓影像的創造，擁有更多自我的因素。

2012 年舉辦《敘事‧台灣》攝影個展並出版專集，是這個主題的首次較完整性發表。近幾年來不再行色匆匆拍照，而是將敘事概念放在心中，地點、題材不再局限，更自由尋覓閱讀生活的故事。舉例來說：《小草的優雅》拍攝地點為桃園龍潭，晚秋蕭瑟田野中，在晨光中枯黃小草優雅的身軀隨風搖曳，讓我感嘆生命輪迴和土地的美麗。《大佛像》拍攝地點為中國上海，節慶中陳列的大佛像金光耀眼、威嚴震懾，不懂事的兒童卻把它當為嬉戲場所，形成一幅極不對稱的景象。《工人群像》拍攝地點為中國山西，展場完工後應雇主要求拍個紀念照，背景為鮮紅色的大陸國色，搭配工人們滄桑和安於現實的面龐，似乎對社會主義工人掛帥時代的一種對照和感嘆！《復仇者》拍攝地點為香港，熱門電影的大型公仔正在展覽，有一位光頭大叔恰巧站在公仔大鐵鎚下，形成詼諧有趣畫面。《歲月鑿痕》拍攝地點為台北陽明山，我在閒暇時喜歡動手做木工，所以工作室有許多鑿子、鎚子、鑽子⋯⋯，那天在一家店裡看到陳列的鉗子、湯匙等金工用具，不經意的組合和不完美的排列，有別於商業攝影，卻有一番自然與生活意象，想像歲月與職人曾經使用留下的刻痕，吸引我沉浸在故事之中。有時候自己喜歡的作品，常是貌不驚人的照片。在按下快門之前，已經觸動自我經歷深層想像與溫暖的感動。

For me, art creation is the refinement and reflection of life.

The creation and activities of art can't be independent of the pulse of society. The power of art creation comes from humans' need for beautiful things and life. Art activities can satisfy and soothe the mind, bring hopes and energy, and make art creation valuable and meaningful. Photography features a fast and sharp reality and cultural and social narrative. The media of photography are suitable to convey and record real life. If well used, these characteristics can arouse visual recognition and resonance and make it easier to show concern for society and witness history.

Scenes change at different times of the day and with four seasons. Plants also follow the life circle of "birth, aging, sickness, and death". The moment of photographing things is the real recording of scenes. With the elapse of time, things change. The original reality turns into fantasy and becomes a memory. But the narrative of the works and the meaning to the photographer are eternal.

I like the narrative technique. I have kept taking the series works of "Narrative" for more than forty years. At first, I simply wanted to capture the feeling of "living" or "life" and kept a "free" creative mind, expecting to endow the creation of an image with more personal elements.

In 2012, I held the photography exhibition "Narrative, Taiwan" and published a photography album. It was the first complete publication on the topic. In recent years, I have not taken photos in a hurry but have born the narrative concept in mind. Without the limit of places and topics, I can look for and read the stories in life more freely. For example, "Elegance of Grass" was taken in Longtan, Taoyuan. In the bleak field of late autumn, the withered yellow grass danced with wind elegantly in the morning light. I sighed for the circle of life and the beauty of the land. "Great Buddha Statue" was taken in Shanghai, China. At the festival, the great Buddha statue on display looked dazzling and majestic. However, the ignorant children played around, forming an image of contrast. "Portrait of Workers" was taken in Shanxi, China. After the exhibition room was completed, the employer asked the workers to take a memorial photo. In front of the Chinese red were the workers' faces looking content with reality in the vicissitudes of life. It looked like a contrast to and a sigh for the worker-centered socialism! "Avenger" was taken in Hong Kong. While the large action figure of the popular film was exhibited, a bald man stood right under the hammer of the action figure, forming an interesting image. "Chisel Marks of Years" was taken in Yangmingshan, Taipei. I like to do woodwork at my leisure, so there are many chisels, hammers, and drills in my studio. One day, I saw the pliers, spoons, and metalworking tools displayed at a store. The random combination and imperfect display composed a natural image of life different from commercial photography. By imagining the marks left by the professionals with time, I was intrigued by the story. Sometimes the works I love are often those looking plain. Before I press the shutter, they have warmly touched my personal experience and deep imagination.

洗鍊・省思

自序

在大學任教四十年退休，退休後有更多時間整理作品，並回顧自己過往的經歷。發現以往大部分時間花費在教學與行政上，然深究之，教學並沒有影響持續藝術創作，反而幫助我建構創作的學理基礎，尤其是在研究所擔授「影像創作課程」，必需閱讀、蒐集大量攝影史暨影像創作教材，在傳統攝影美學無法滿足與評定現代影像創作情況下，符號學、圖像學、敘事理論等成爲分析、解讀與創作影像的理論基礎，「教學相長」提供自我創作的途徑和養分。再者，作爲一位以創作爲專長的大學教師，爲符合教育部升等及評鑑要求，必需不斷地創作與發表，所以從外在環境與內在自我實現理念的砥礪，四十多年來共舉辦十七次個展，並應邀國內外全國美展、全省美展、國際攝影節暨歷屆教授聯展等展出新作，累積大量作品。其次，多年繁重的行政工作，對於喜愛策展的我提供紮實的實務能力，從策劃、申請、募款、活動規劃、布展等皆能一手包辦。這些都值得感恩與惜福。

「誠實地面對自己、面對作品、面對觀眾」，是此次應邀國父紀念館中山國家畫廊展出自己所抱持的態度。展覽內容有四個單元：《虛實映象》、《花情》、《城市定格》、《生活符碼》。從數百件作品中選出，其中包括早期作品和近年尚未發表的新作。綜觀展出的方式與想法如下：

一、單元主題主軸採用線性方式，期望簡單易懂地傳達方法，更能和觀眾互動、溝通。

二、主題涵蓋同一時期或較長時期（如《城市定格》、《生活符碼》等持續創作，時間超過 30 年以上）。

三、以系列、組合編排方式來說故事。

四、每張作品扮演強化整體概念的角色，不凸顯單張作品畫質或視覺張力，如《生活符碼》系列中 60 days 由 60 張作品組成，其中有許多張手機拍攝作品，訴求生活化的隨興與臨場感。

五、因爲展覽有回顧性質，所以採多主題方式整理爲單元，而書籍編排則以交錯主題形式呈現。

最近參觀幾位前輩大師九十歲回顧展，發現他們七十歲時都正值創作旺盛時期，給我很大的啓發和感動。此次有幸應邀在國家級畫廊展出，《淬鍊‧省思》的展覽主題，就是對個人七十歲暨創作四十載的省思，暨凝聚未來創作再出發的動力。

I retired after teaching at university for forty years. After retirement, I had more time to organize my work and look back on my experience. I found I spent most of my time on teaching and administration. However, teaching didn't affect my continual art creation but helped me construct the theoretical foundation in creation, especially when I gave the course "Image Creation" in the graduate program. I had to read and collect a large number of materials on the history of photography and image creation. When traditional photographic aesthetics can't be applied to meet and assess the modern image creation, semiotics, iconology, and narrative theories become the theoretical foundation to analyze and interpret the creative images. "The mutual benefit of teaching and learning" provides the pathway and nutrient for personal creation. Moreover, as a university teacher with the talent for creation, I have to keep creating and publishing new works to meet the promotion and assessment requirements of the Ministry of Education. With the push from the outer environment and the concept of personal fulfillment, I have held seventeen exhibitions in the past forty years. I was also invited to exhibit the new works at the national exhibitions, provincial exhibitions, international exhibitions, festivals, and joint exhibitions of professors at home and abroad, and have accumulated a large number of works. Besides, the heavy administration duty has developed my solid practical ability to curate exhibitions. I can take charge of all the processes from planning, application, fundraising, and activity planning, to exhibition arrangement. I appreciate and feel grateful for these experiences.

"To face me, face the works, and face the viewers honestly" is the attitude I hold when invited to exhibit my works at Chungshan National Gallery, National Dr. Sun Yat-sen Memorial Hall. The exhibition is divided into four subjects: "Abstract and Concrete Impression," "Flower Love," and "Freeze Frame of City," and "Life Code." Selected from hundreds of works, the exhibition includes the early works and the unpublished new works in recent years and is presented based on the following concepts:

I. The subjects are arranged linearly. It is expected that the easy and simple way will enhance the interaction and communication with viewers.

II. A subject covers the same period or a longer period. (For example, the creative series of "Freeze Frame of City" and "Life Code" last for more than 30 years.)

III. Stories are told in a series of combined arrangements.

IV. Every piece of work plays the role of strengthening the overall concept without highlighting the quality or visual tension of a single work. For example, in the series of "Life Code," the work "60 Days" is composed of 60 photos. Many of them are taken with a smartphone to appeal to the casualty and presence in life.

V. The exhibition with the retrospection function features multiple subjects.

Recently, I visited the retrospective exhibition of several senior masters at the age of 90 and found that they were in a period of creating prosperously in their 70s. This inspired and moved me a lot. This time, I am honored to be invited to exhibit in a national gallery, the exhibition "Refinement & Reflection". The theme of the exhibition is to reflect on creations through my 40 years of dedication and reflections as a 70-year-old, I hope to condense the motivation for the departure of future creations.

洗鍊・省思

目次 Contents

Refinement 淬鍊

誠摯感謝莊靈、張照堂兩位前輩的提携、指導。
王蘭生館長、梁永斐前館長邀展暨館內同仁襄助。
好友郭英聲、秦偉、王川三位老師寫序推薦。孫維瑄博士專文評述。黃子明老師拍攝影片。
鄧博仁老師帶領優質團隊規劃設計。

I'd like to express my sincere gratitude to the guidance and instruction of the two seniors, Chuang Ling and Chang Chao-tang, to Director-general Wang Lan-sheng and former Director-general Liang Yung-fei for their invitation, to the staff of the hall for their assistance, to my good friends, Quo Ying-sheng, Chun Wai, and Wang Chuan for writing the prefaces, to Dr. Sun Wei-shiuan for writing the commentary, and to Mr. Teng Po-jen for leading the outstanding team to plan and design the exhibition.

Kang Tai-sen

康 台 生

省思

& Reflection

藝術創作對我而言是生活的淬鍊和省思

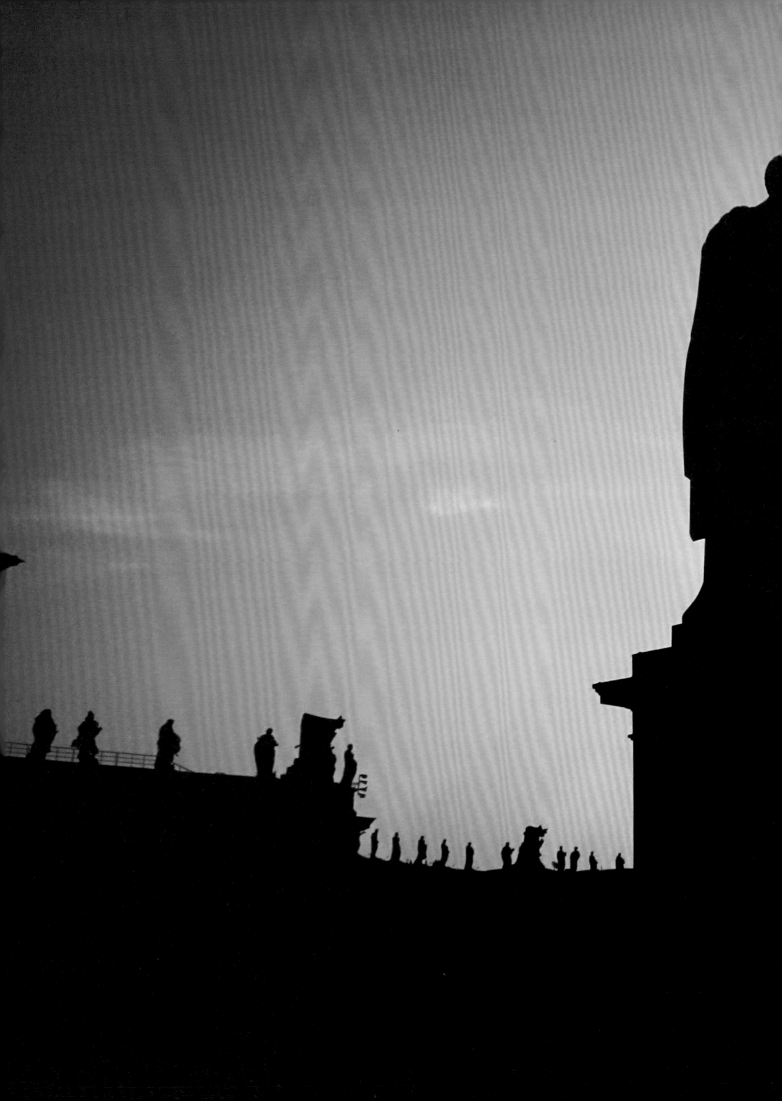

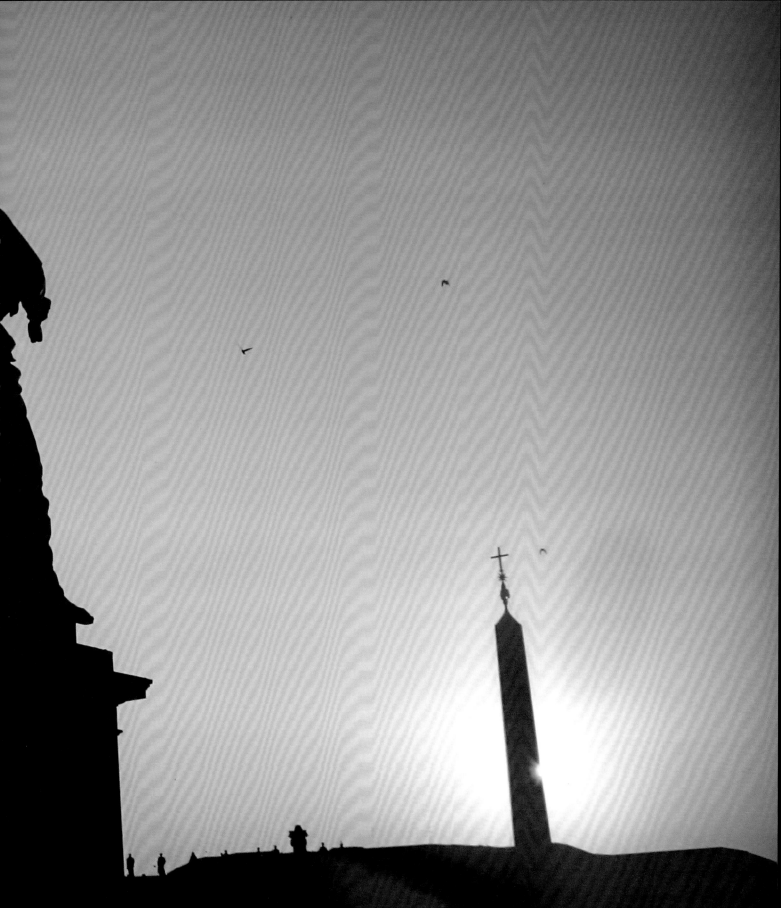

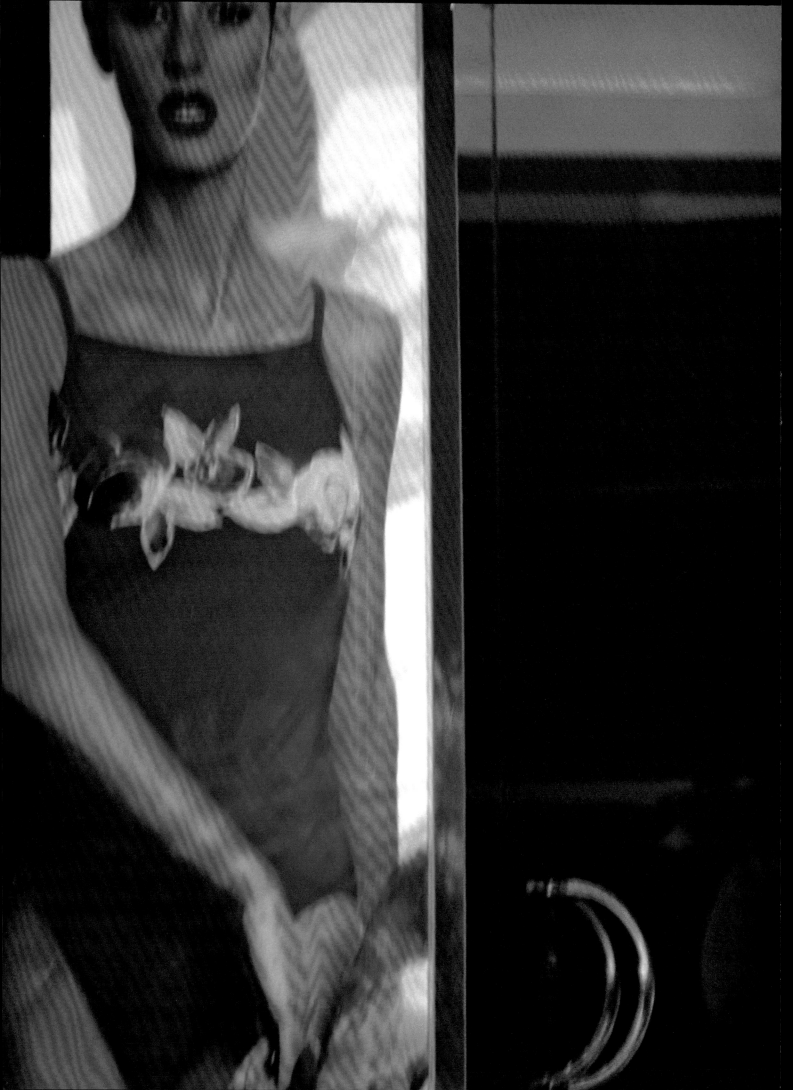

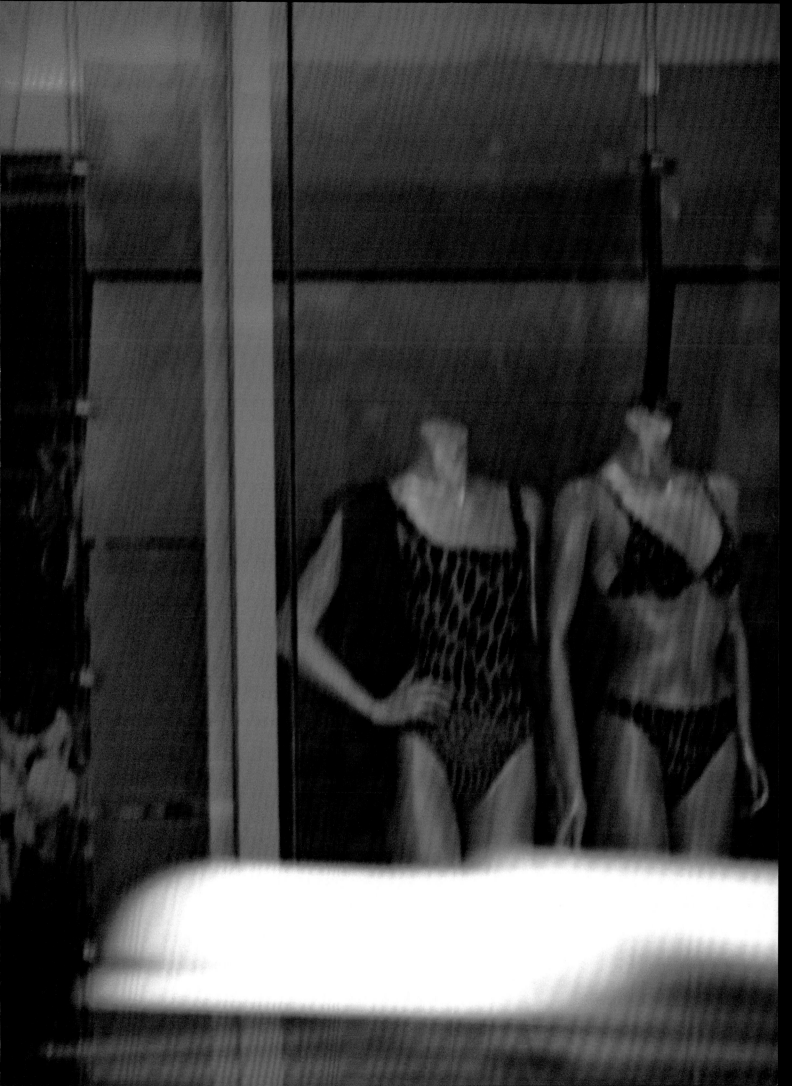

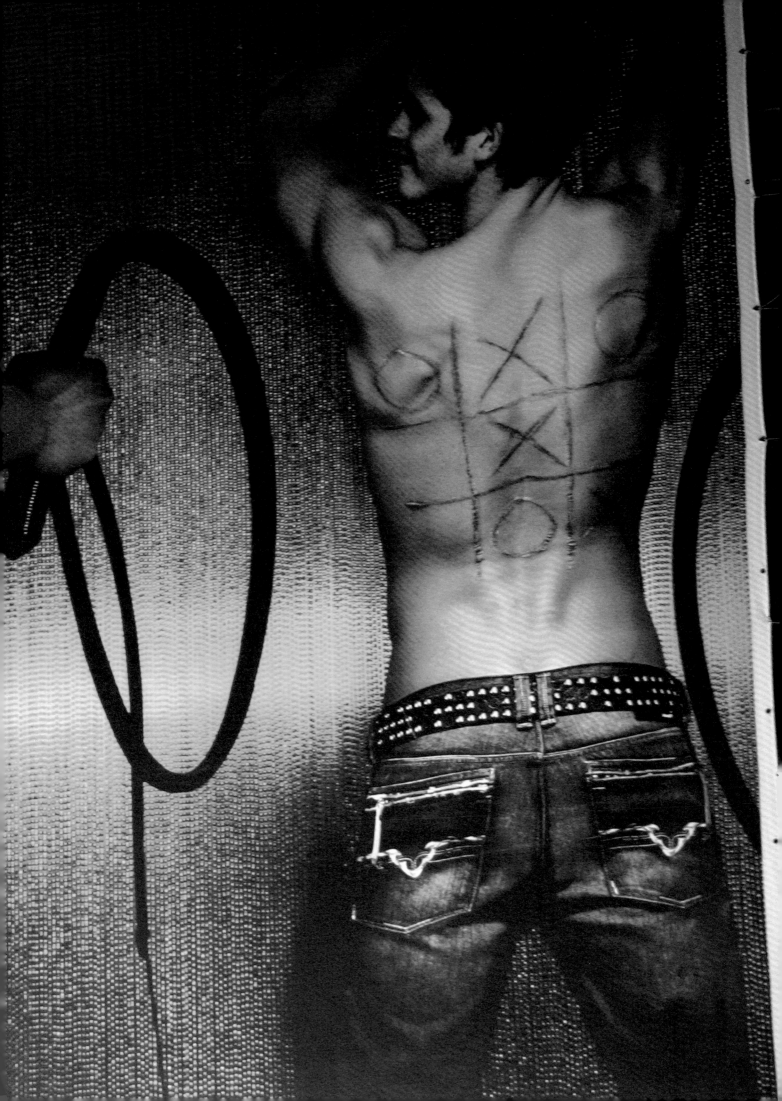

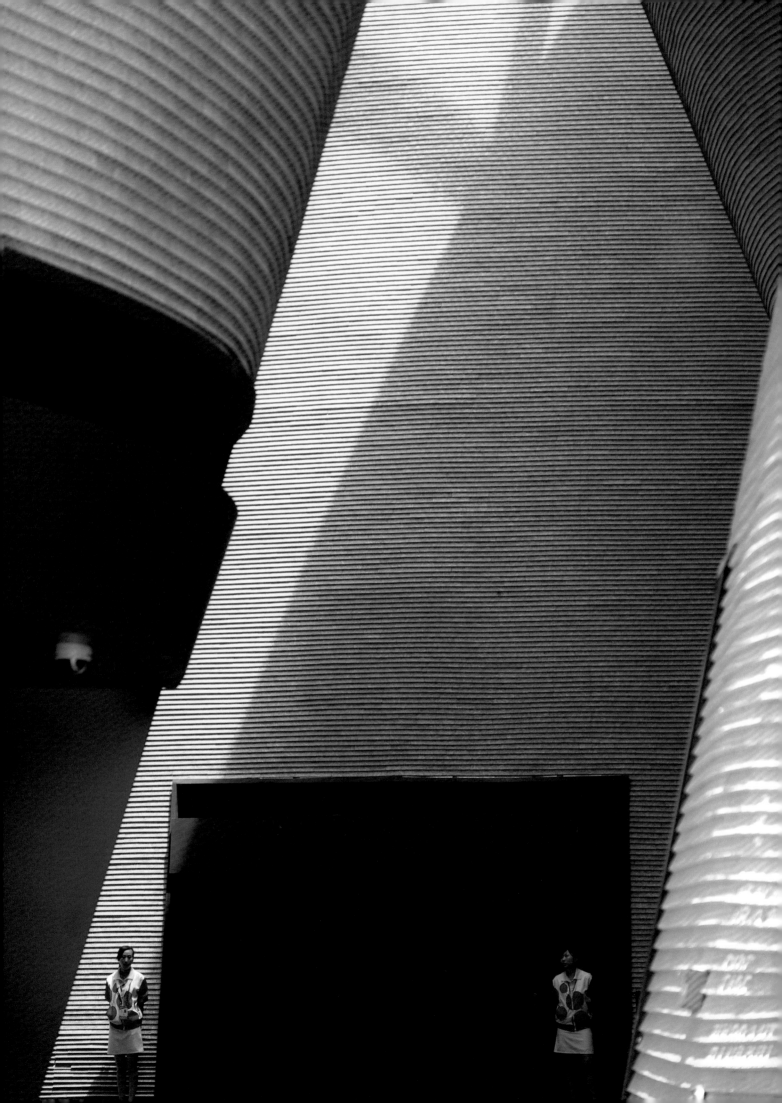

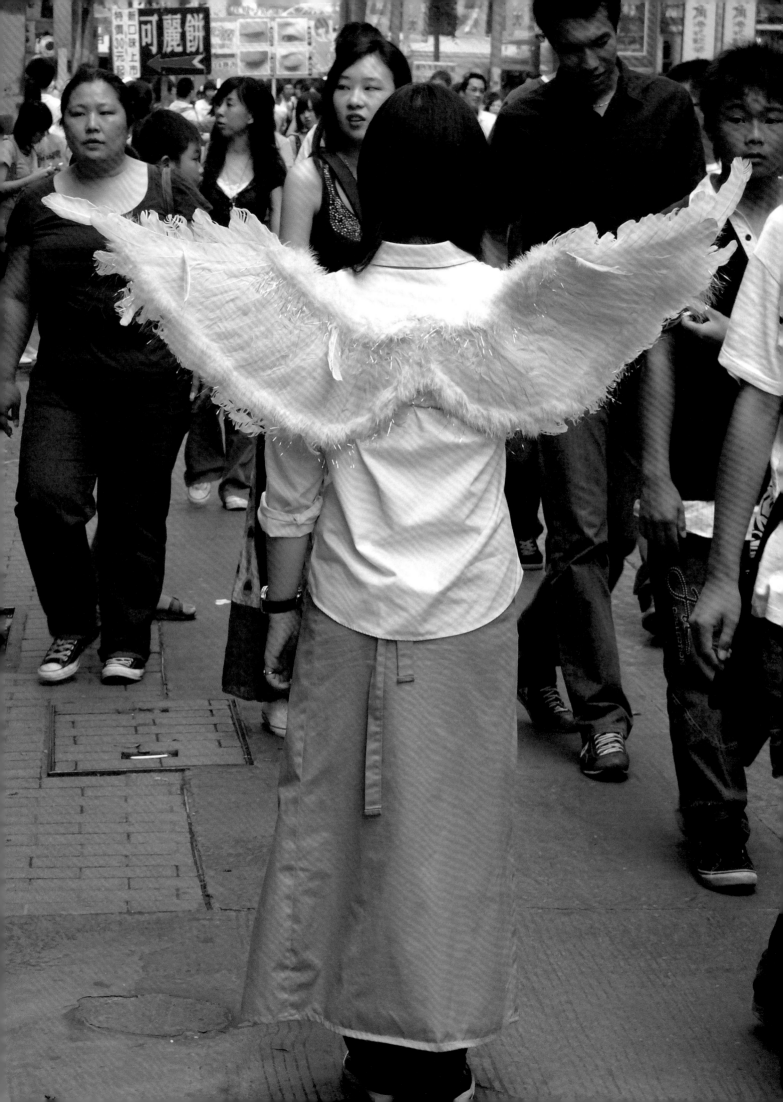

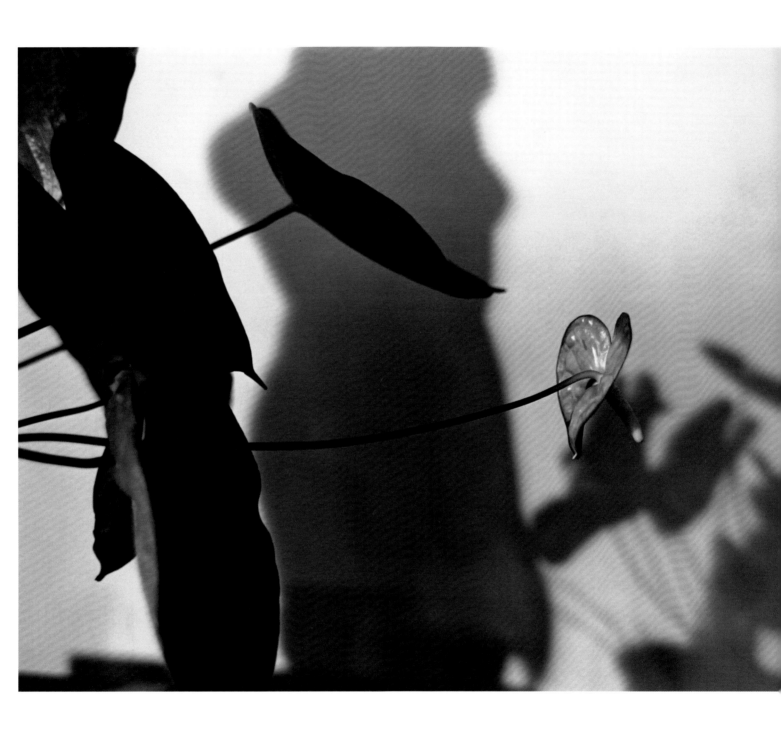

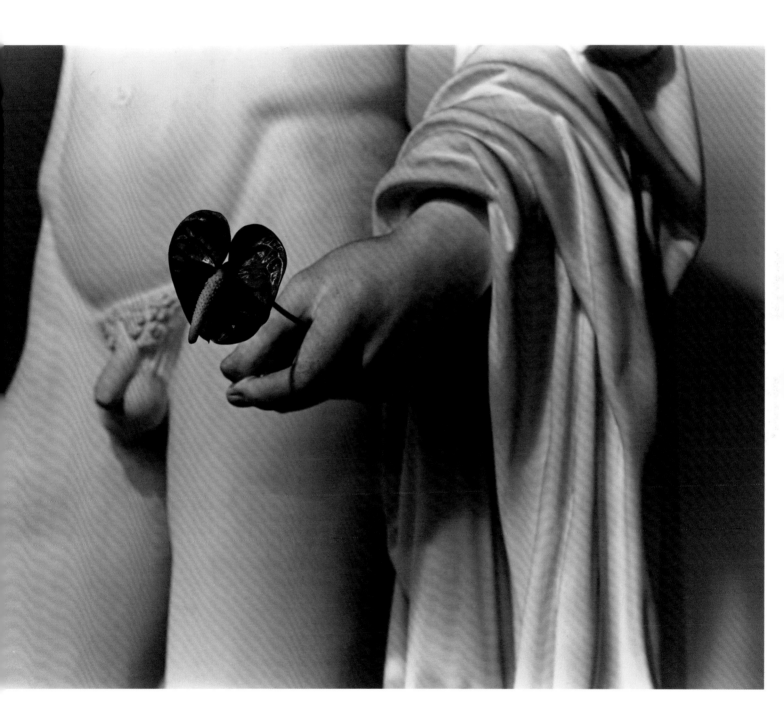

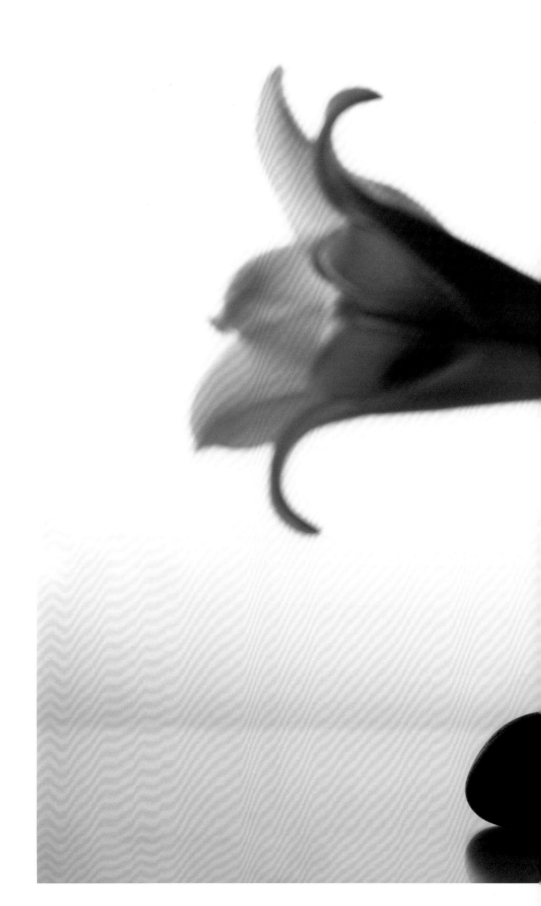

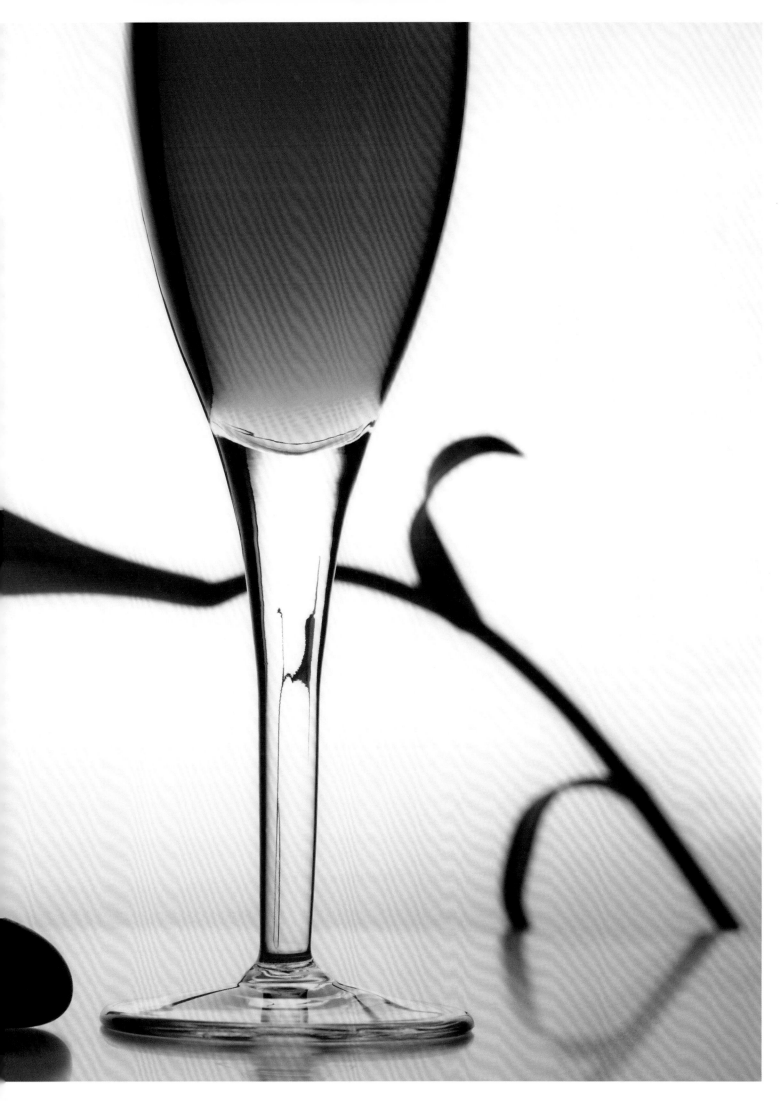

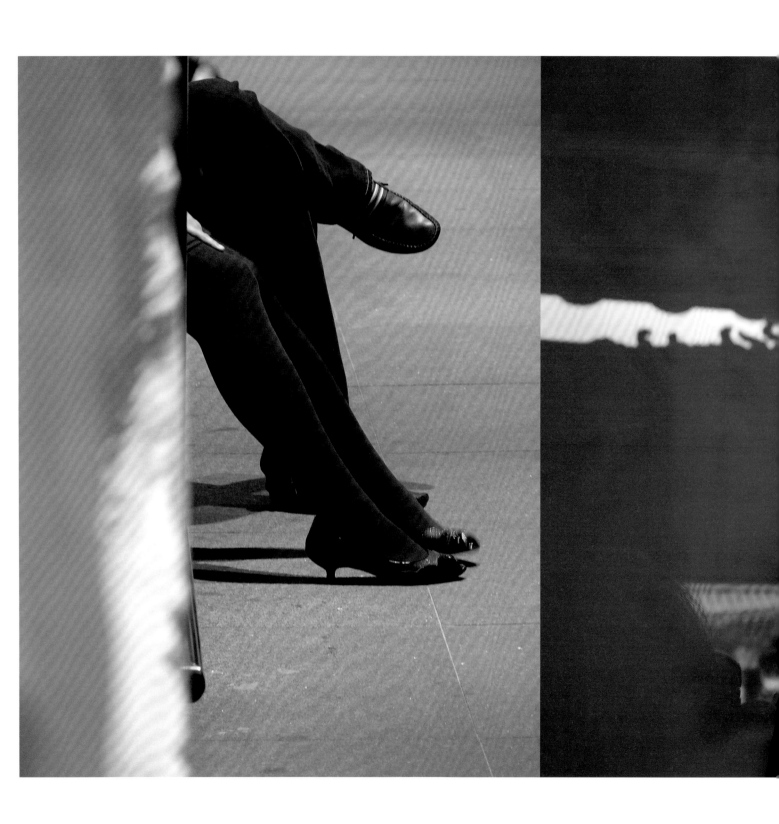

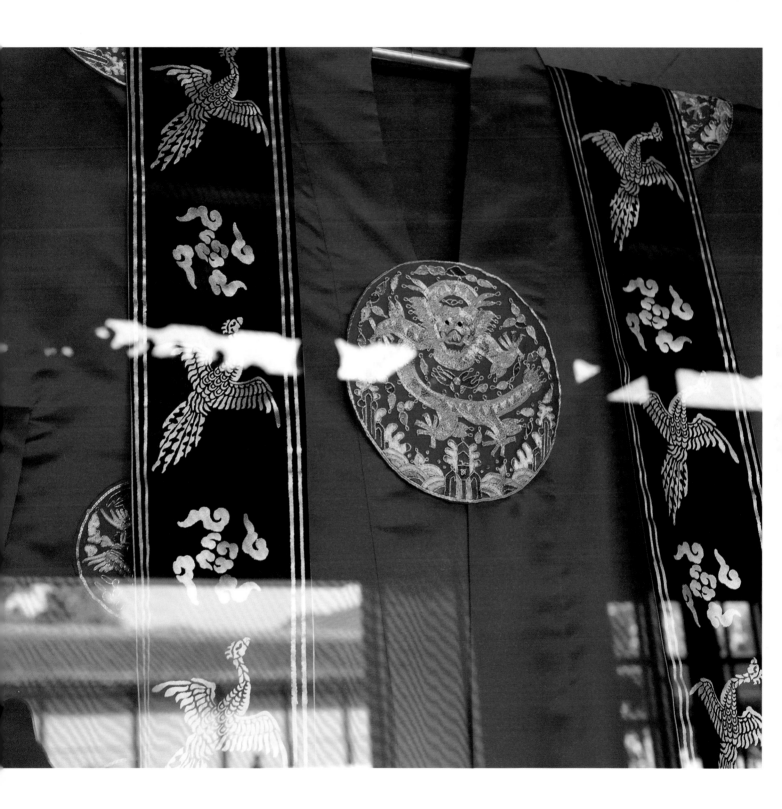

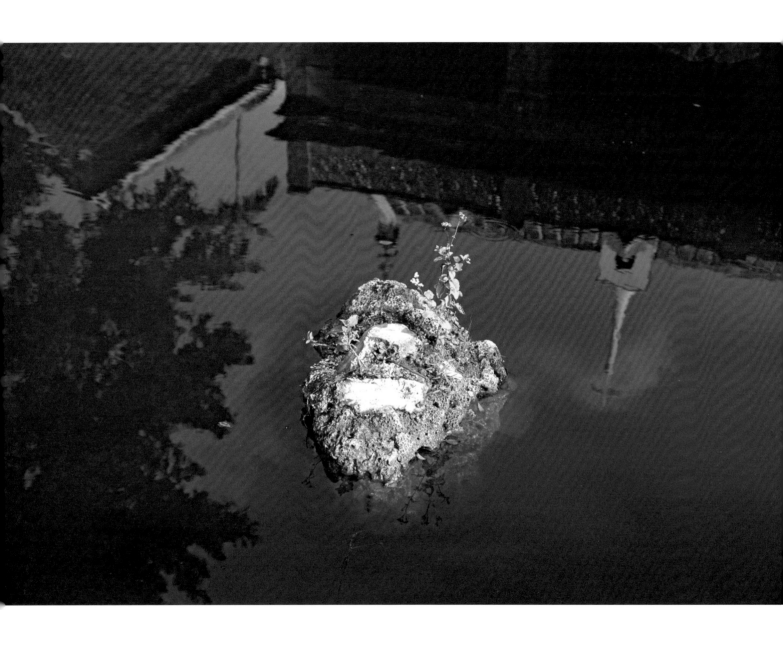

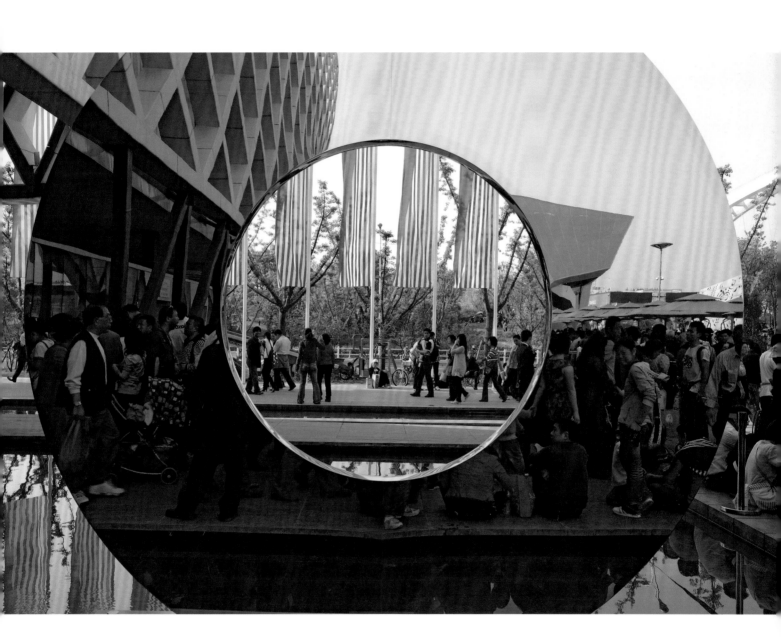

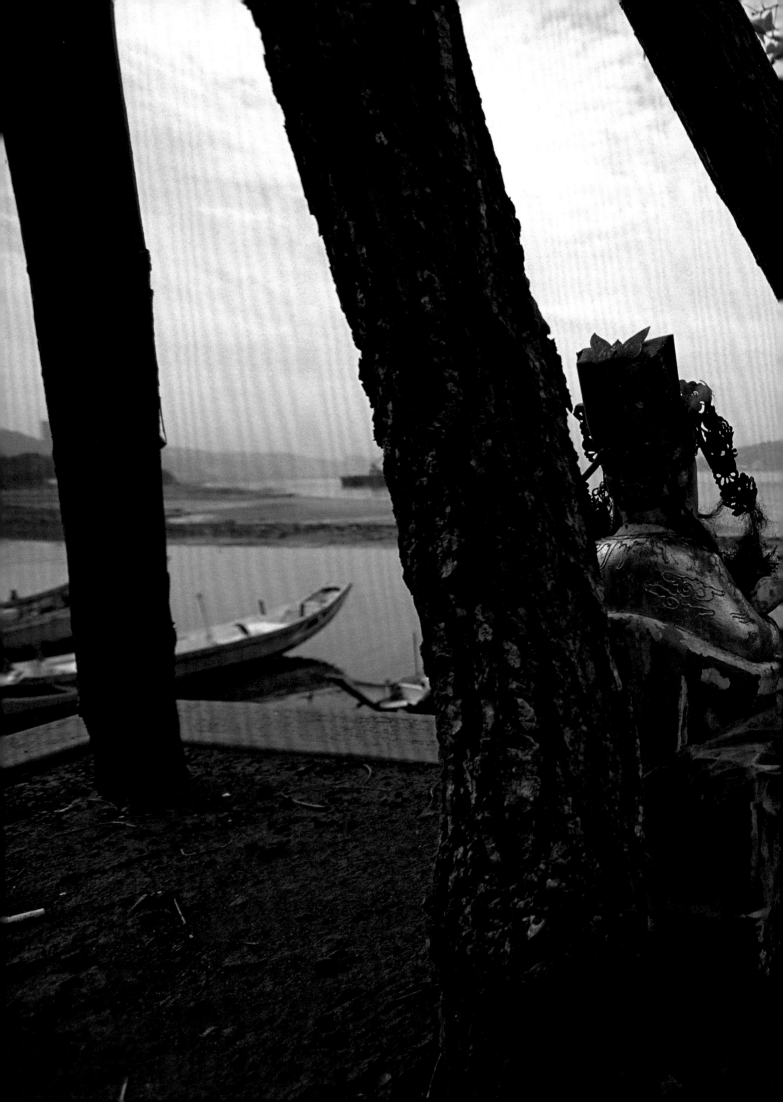

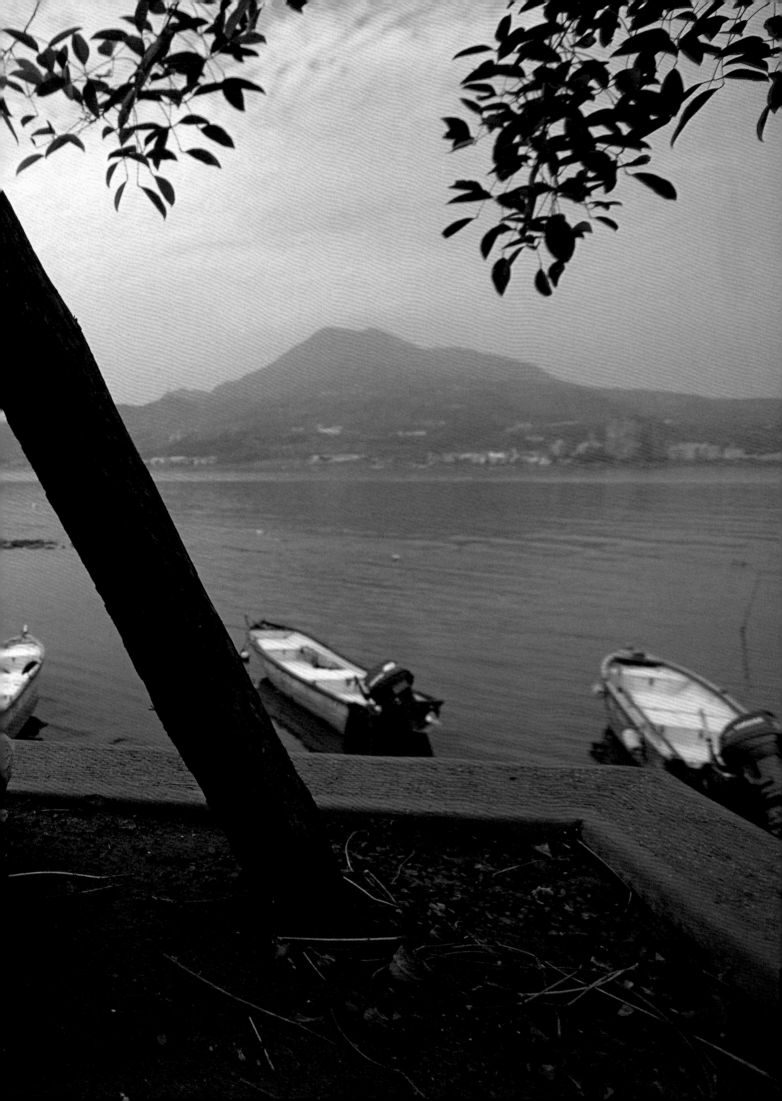

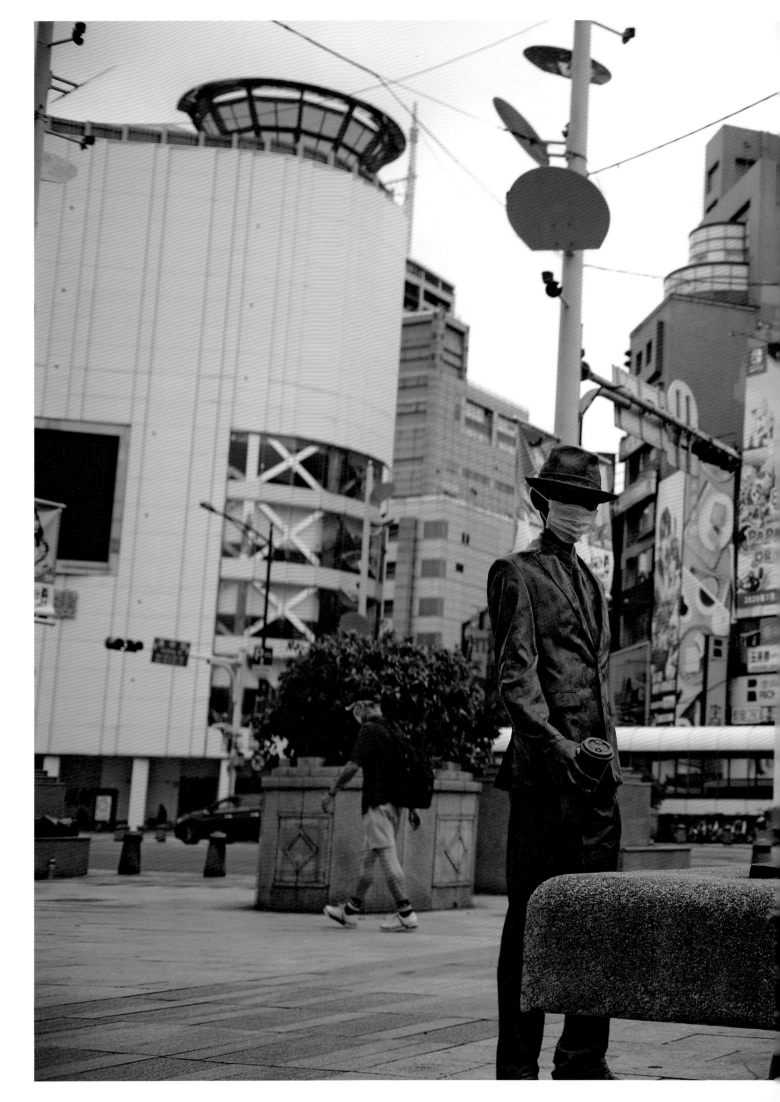

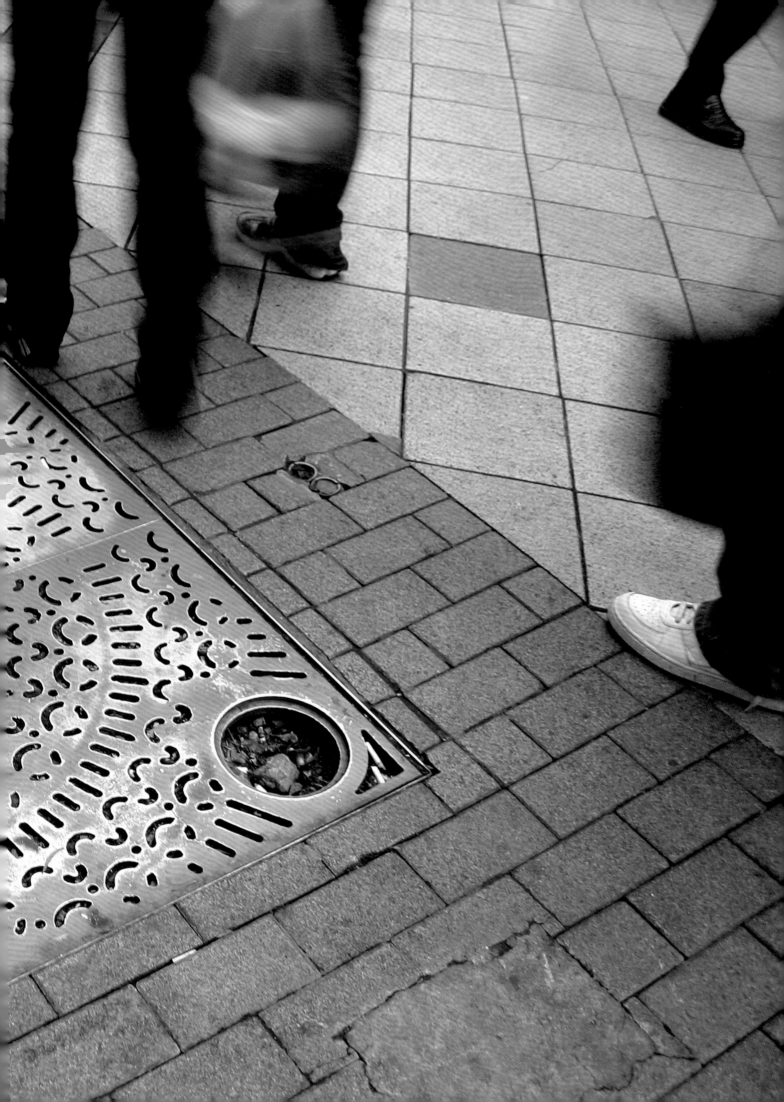

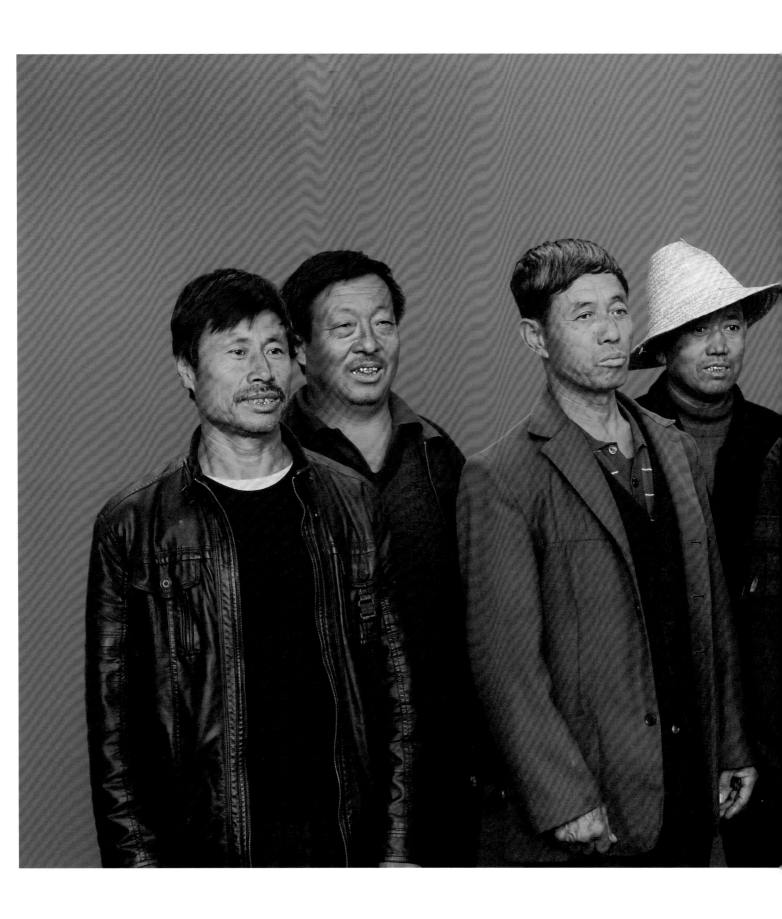

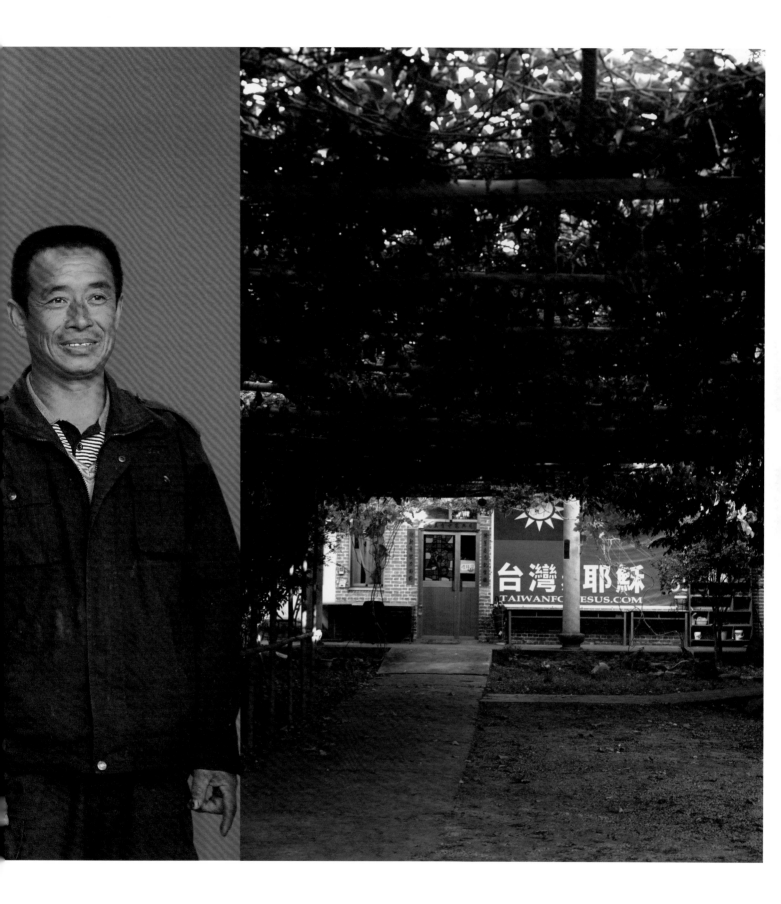

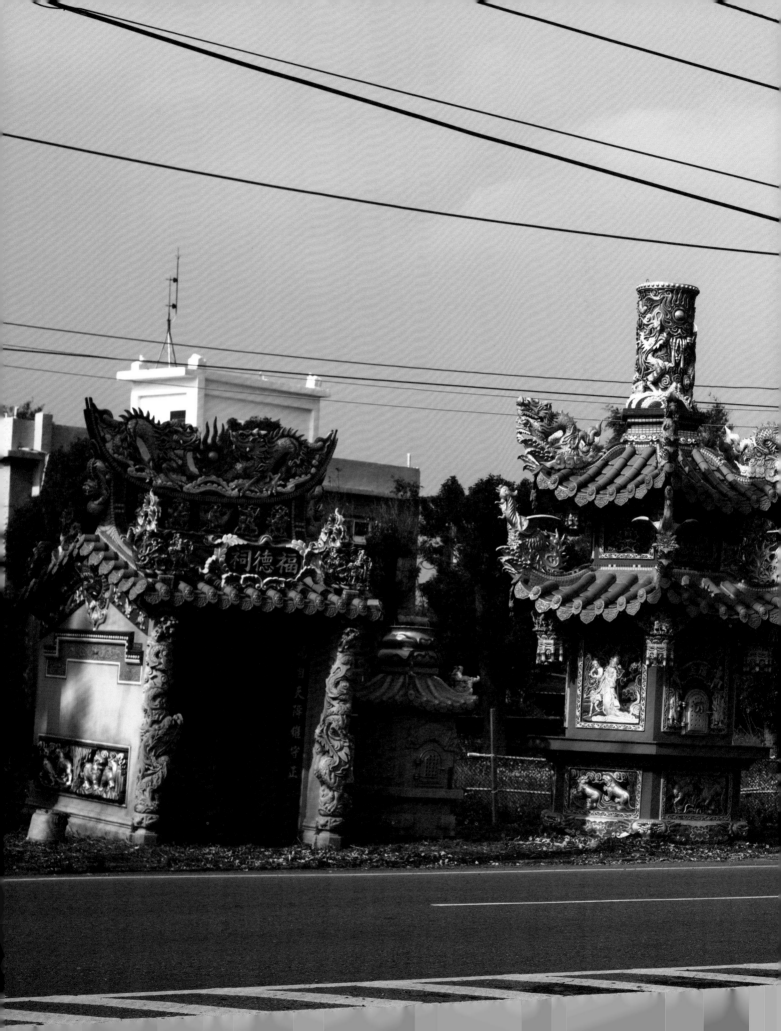

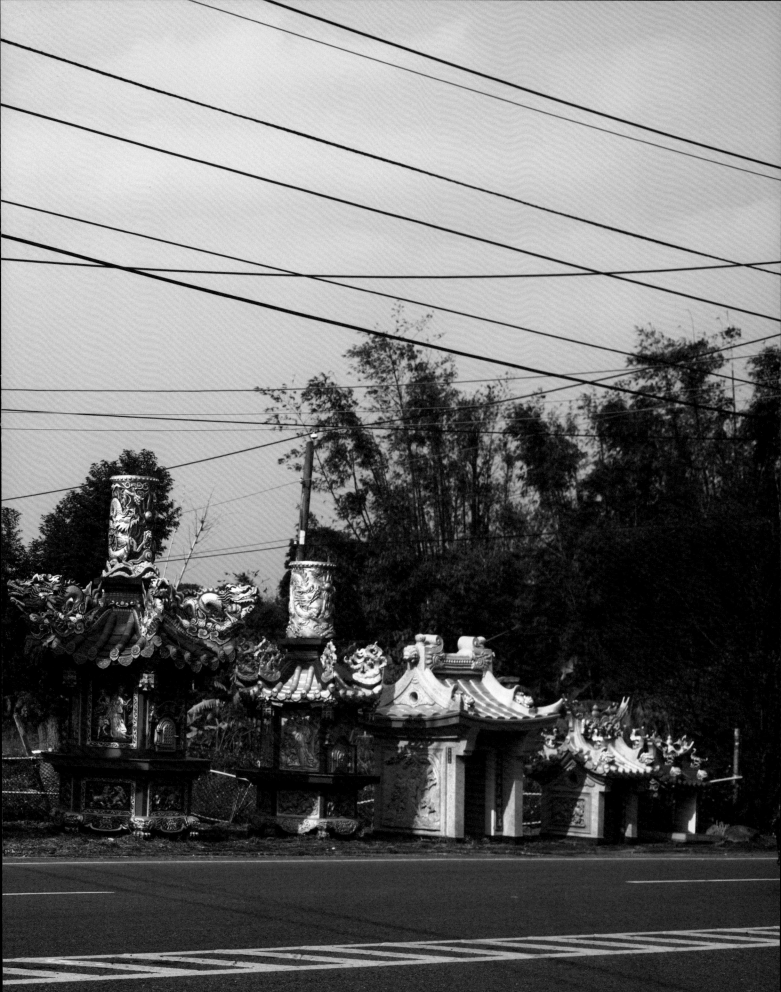

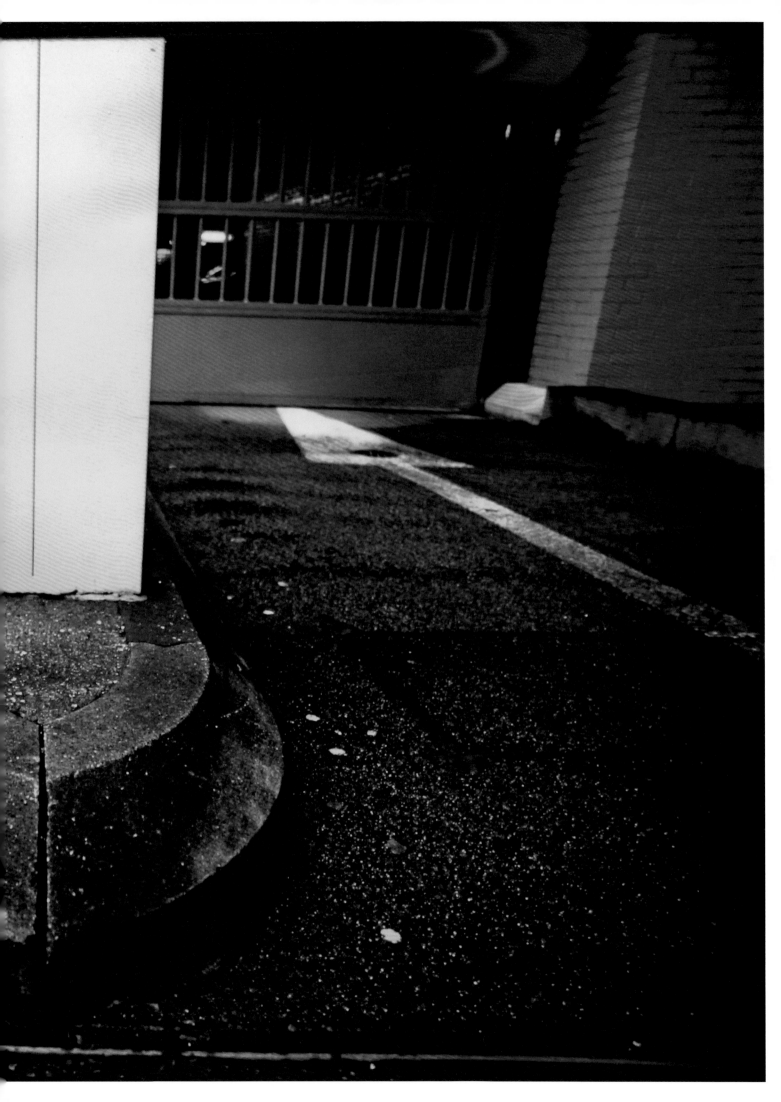

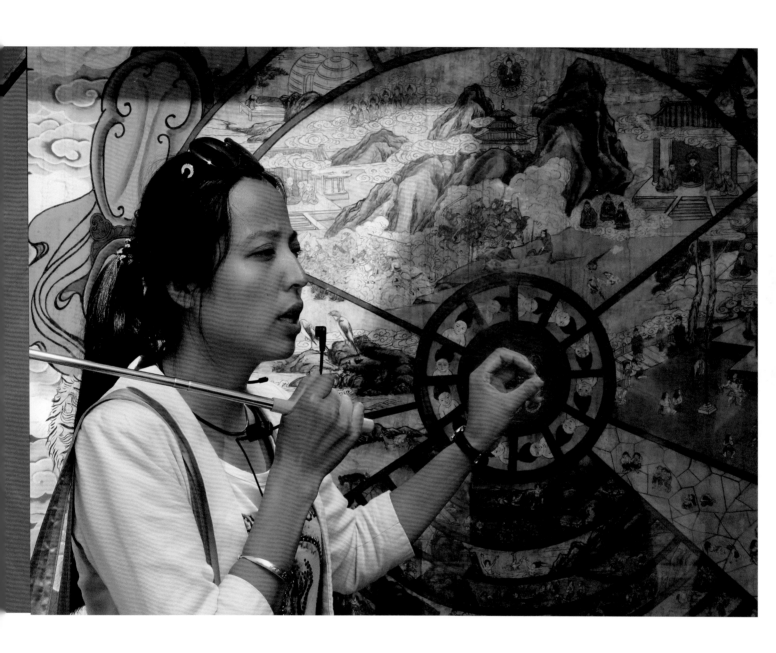

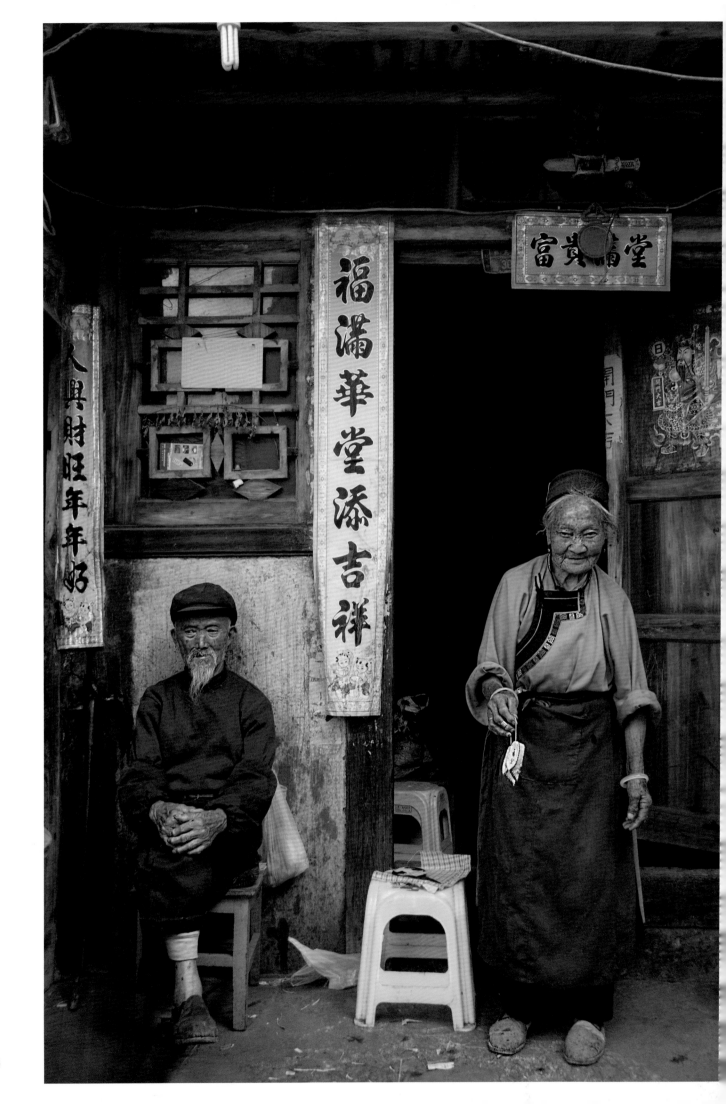

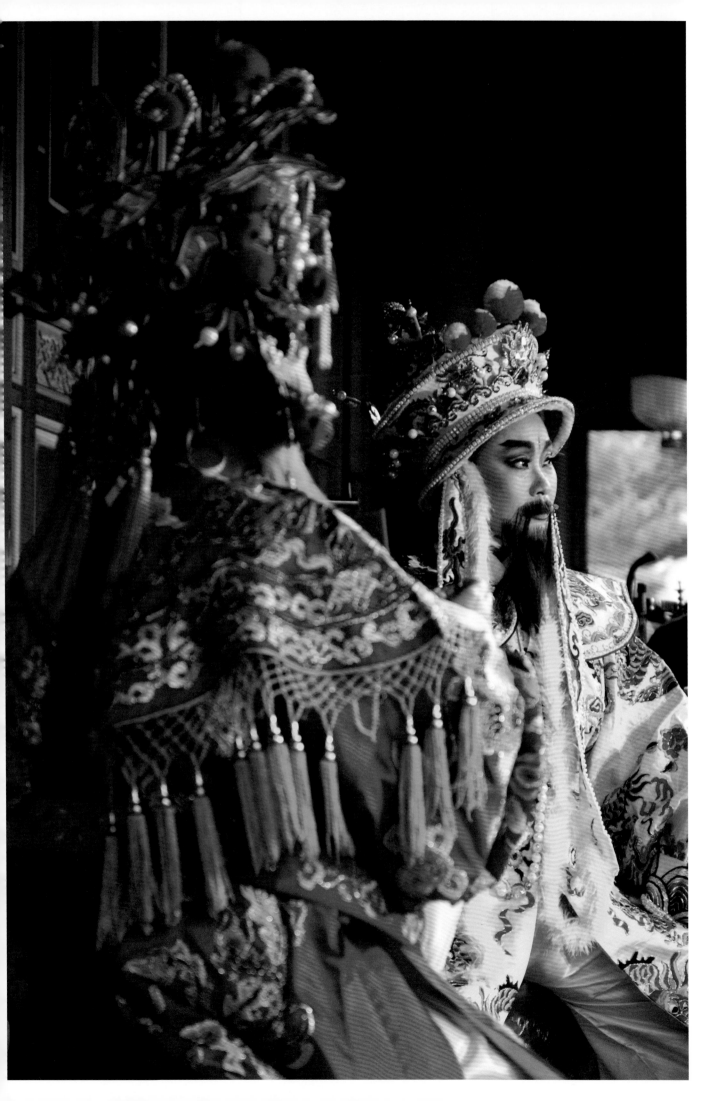

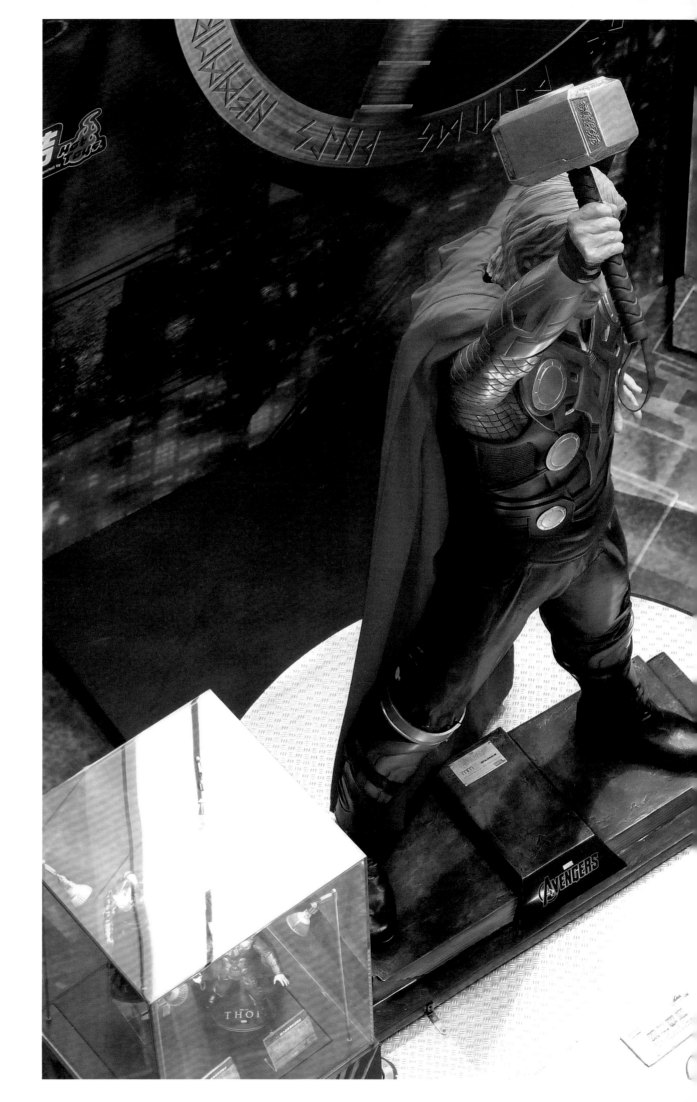

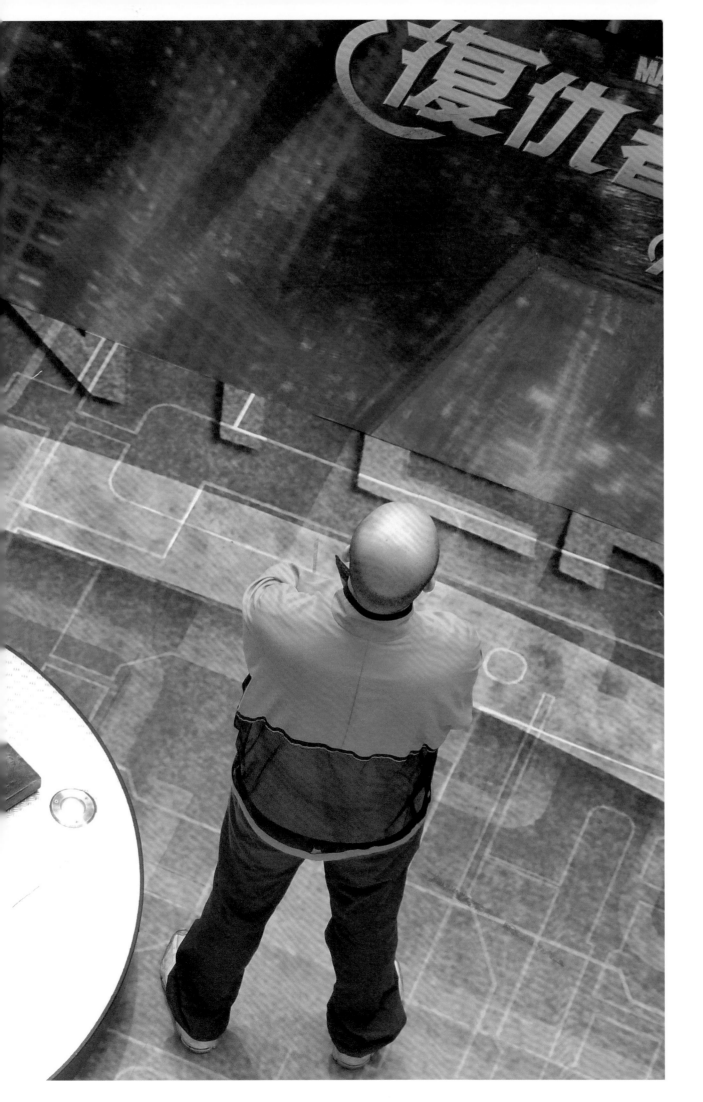

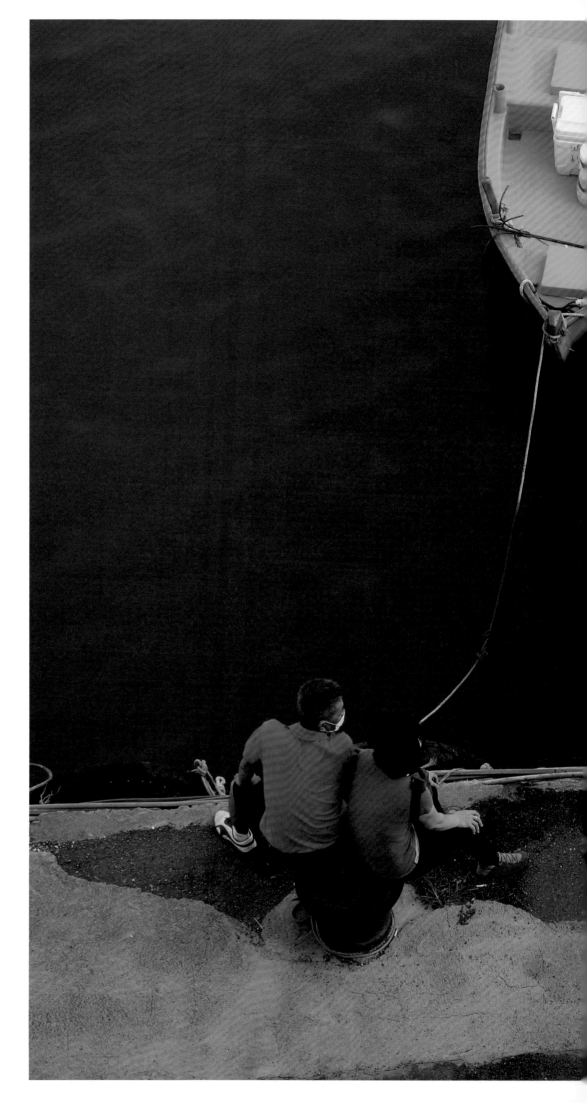

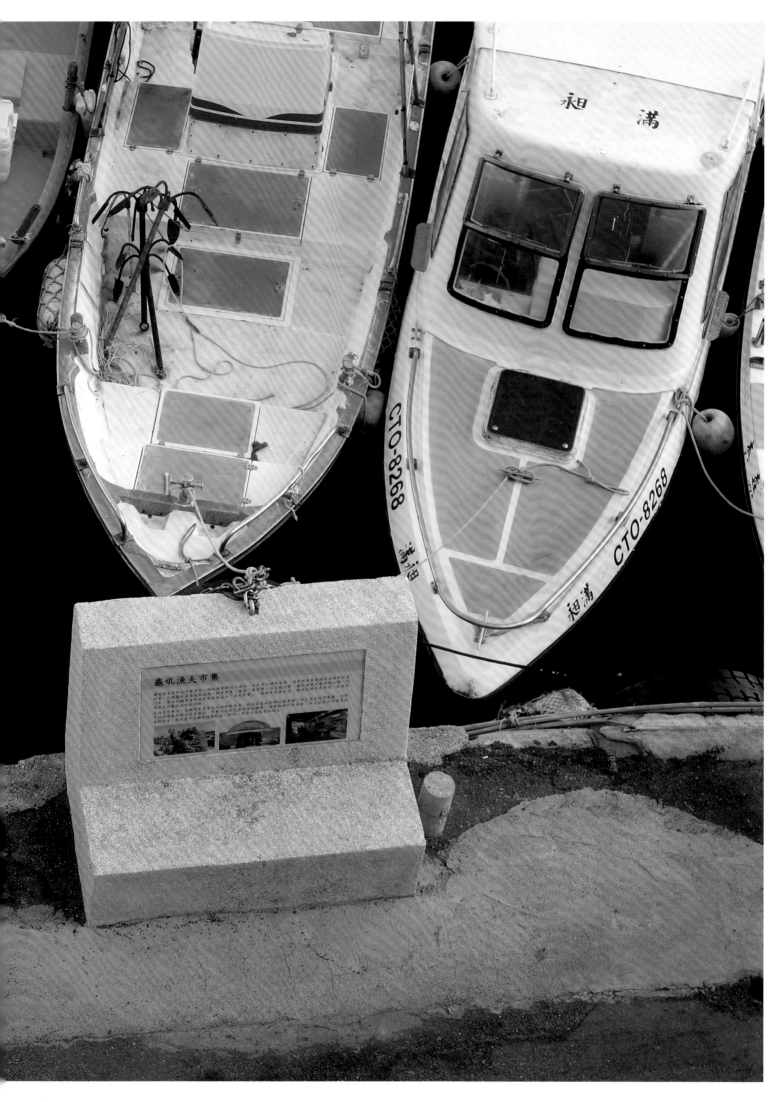

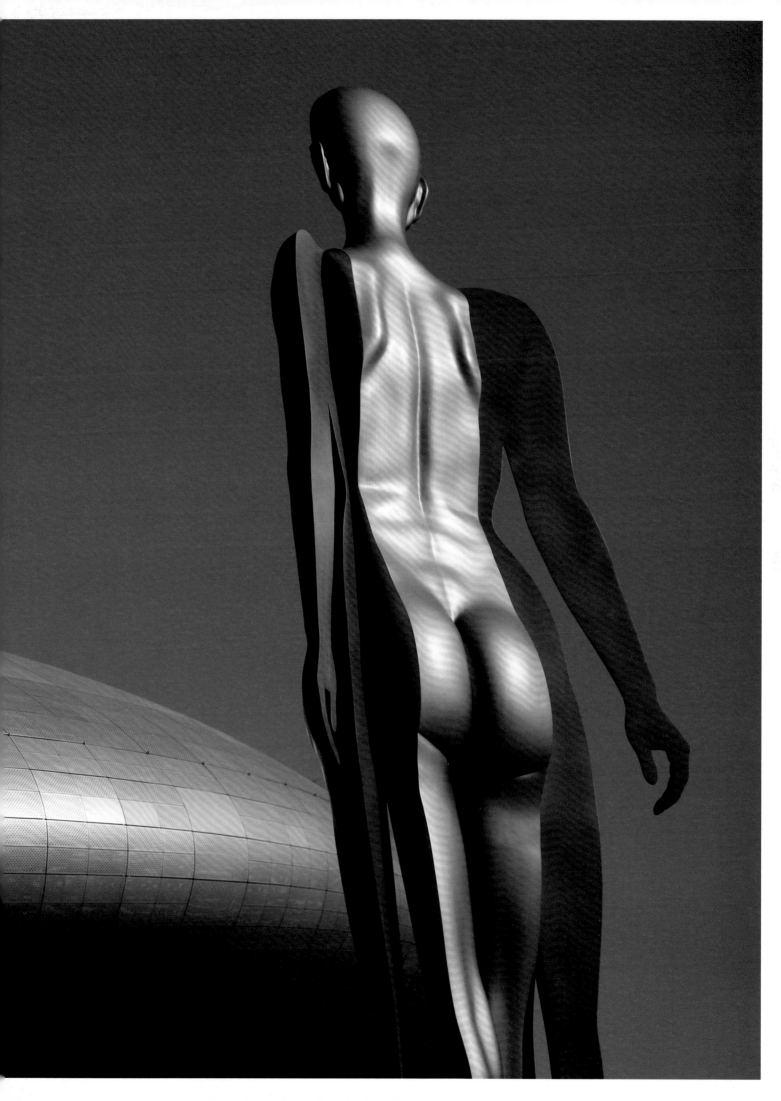

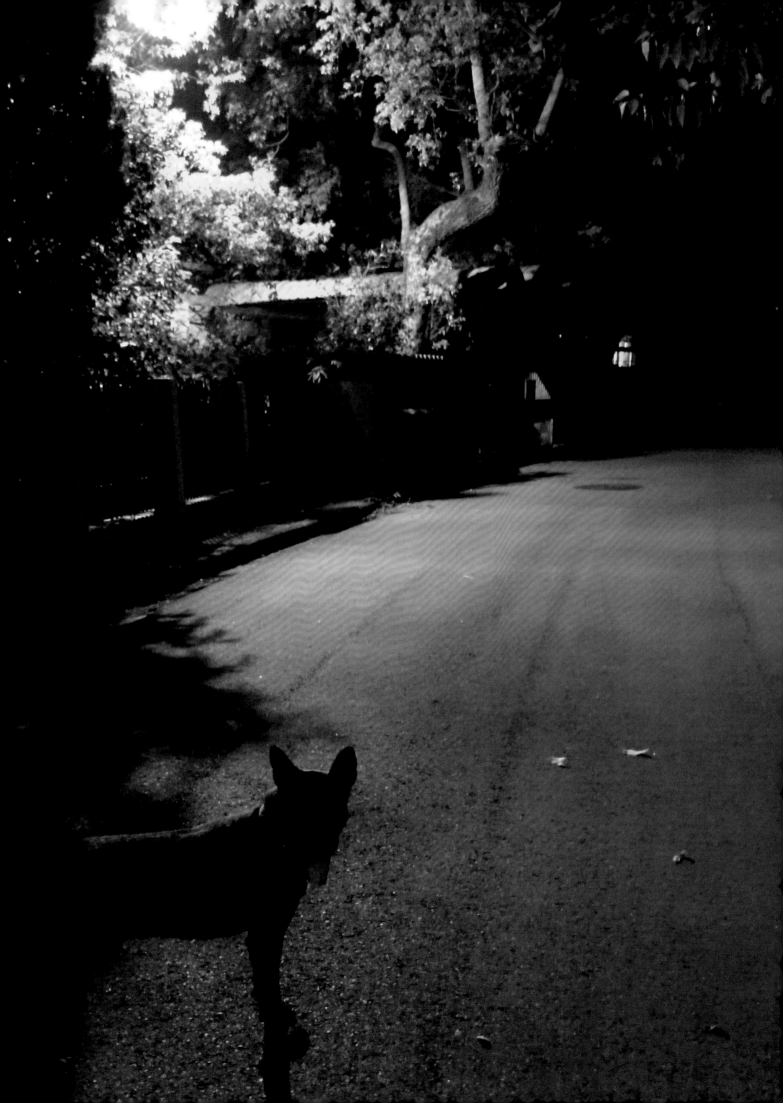

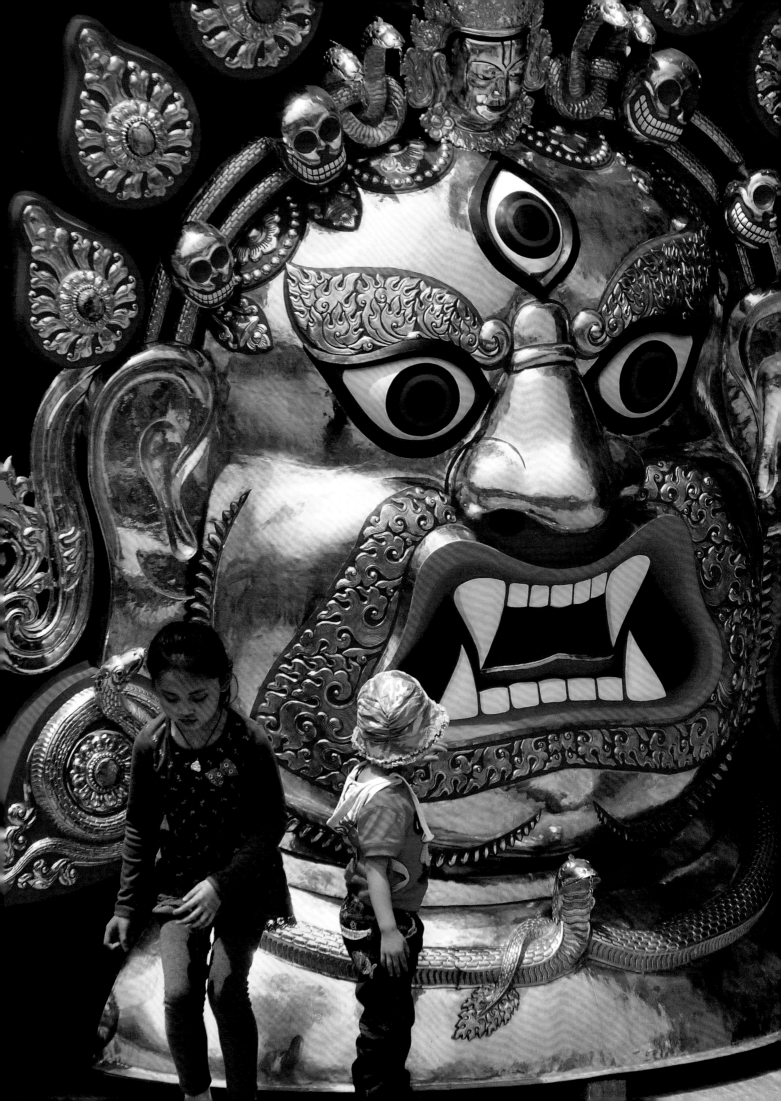

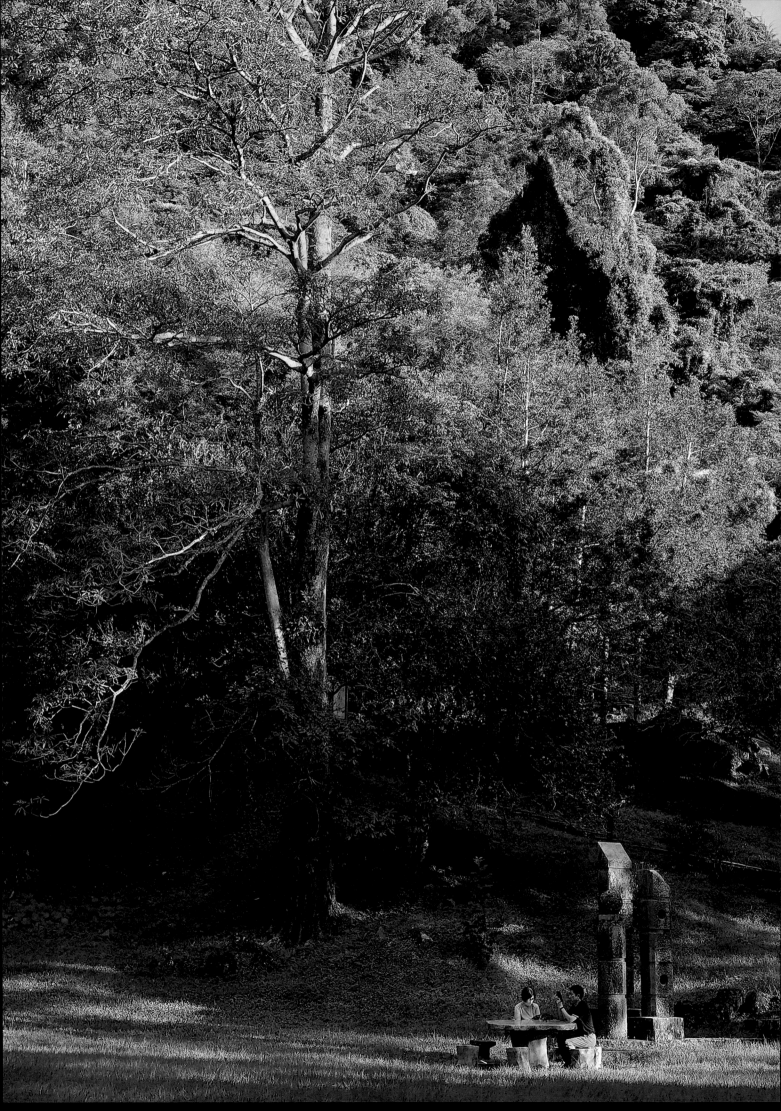

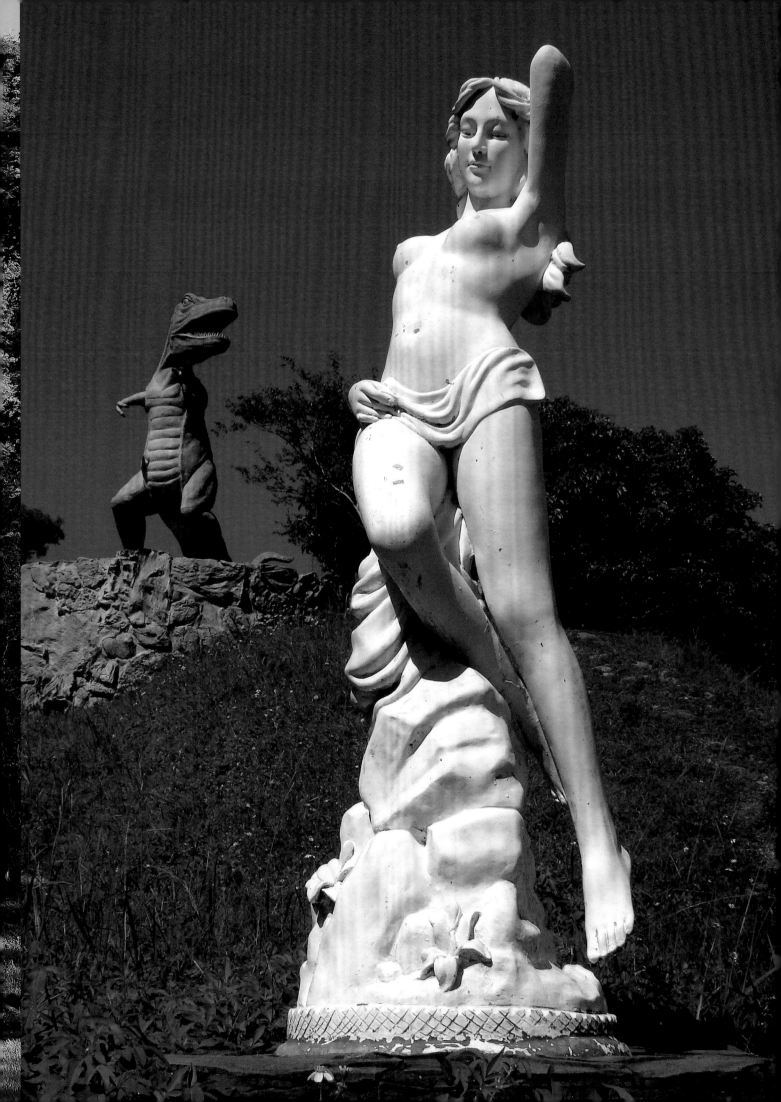

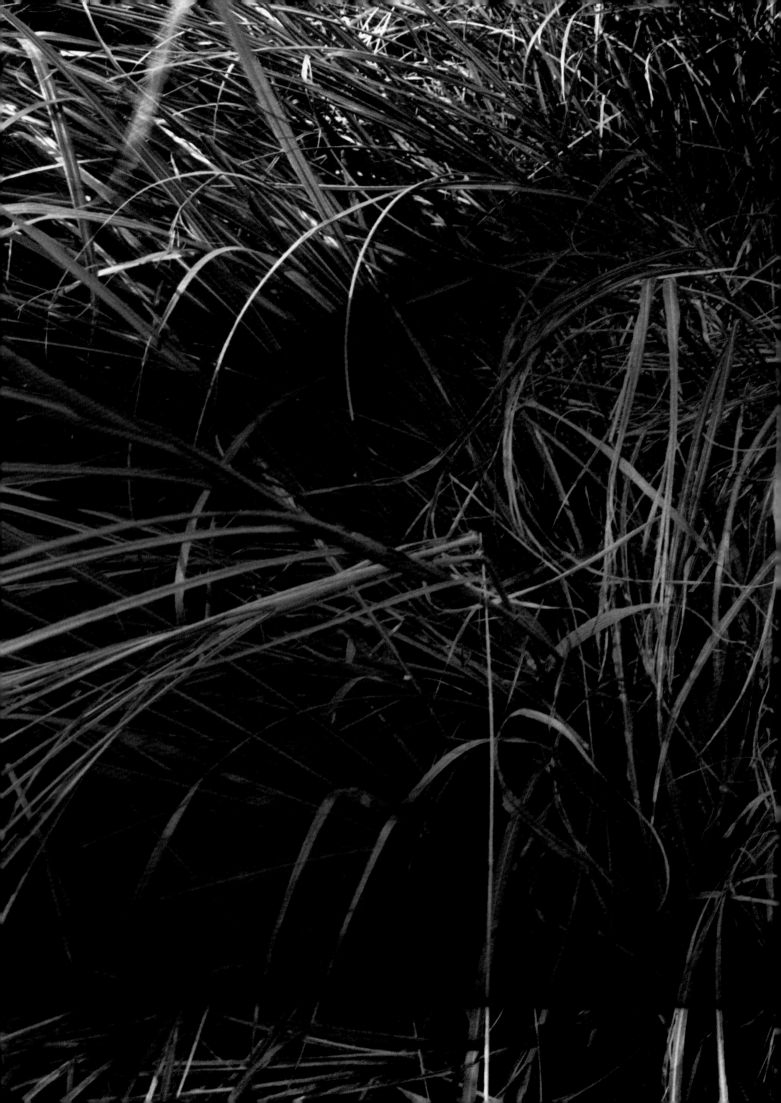

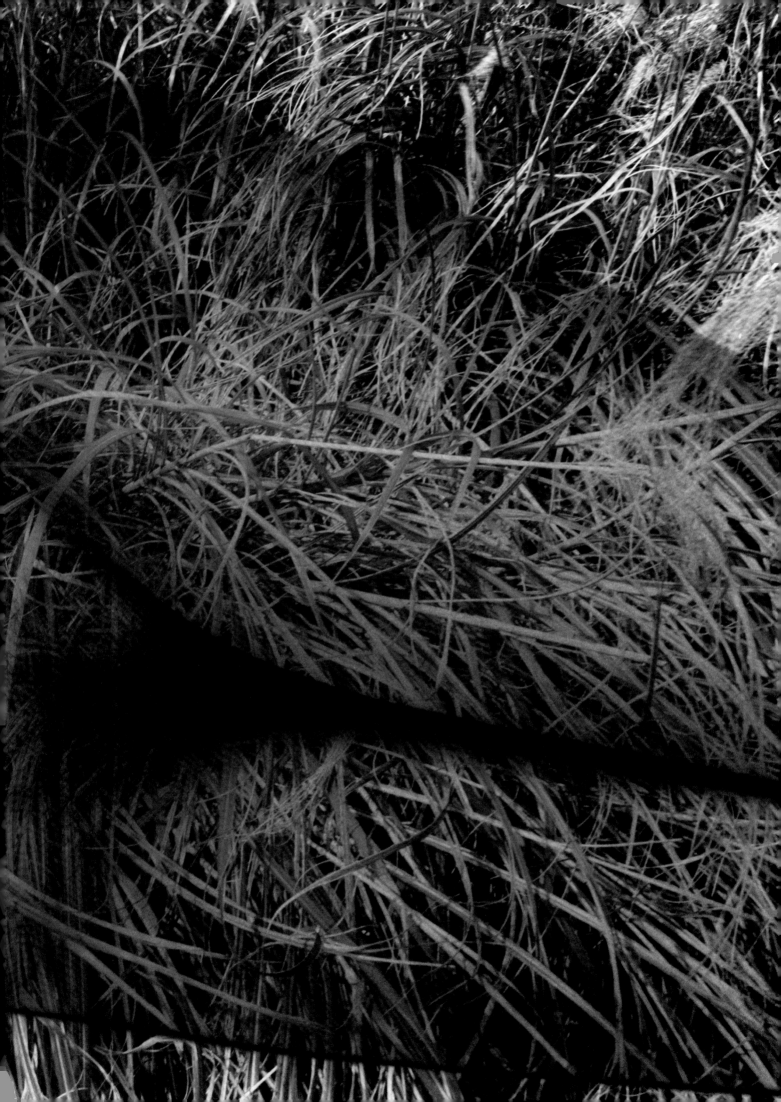

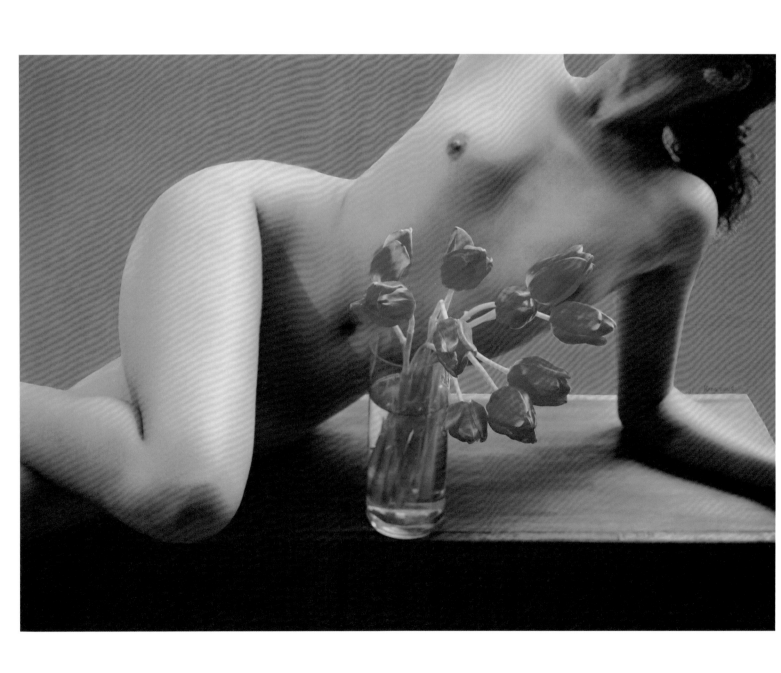

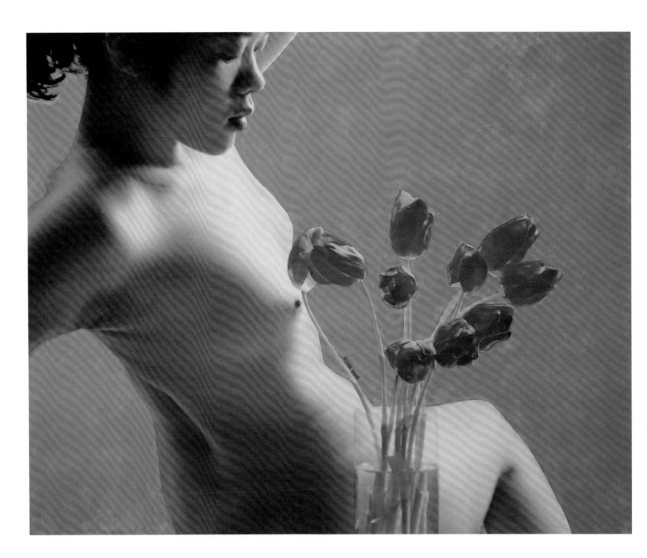

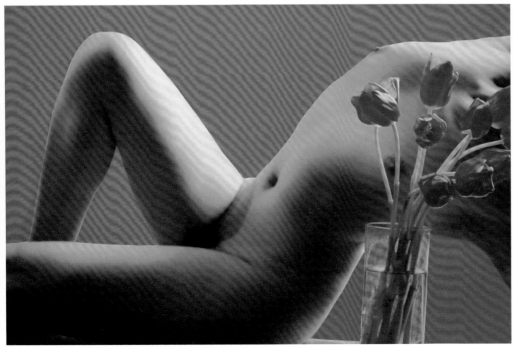

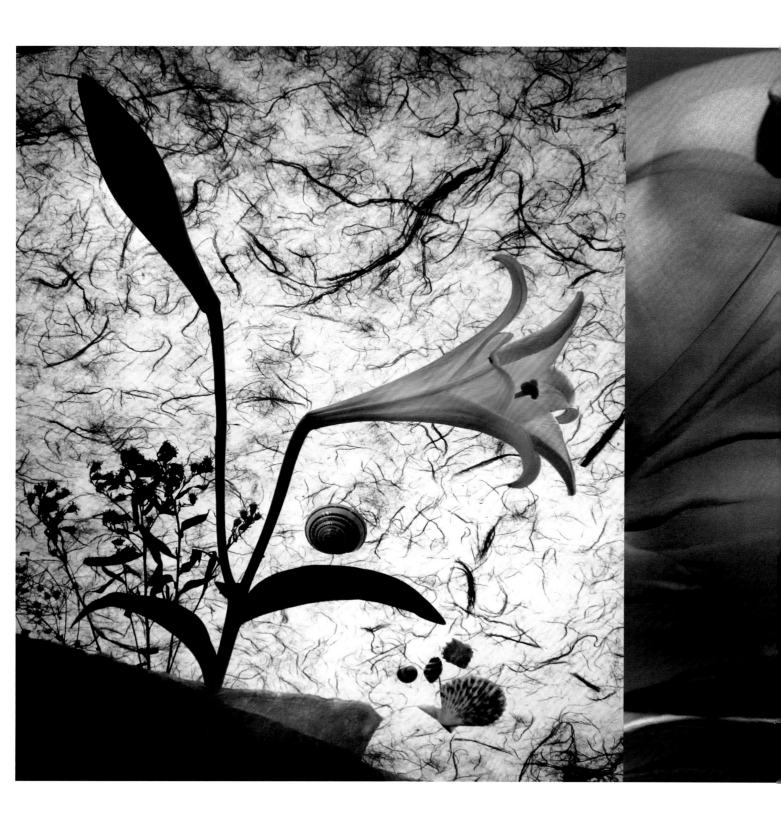

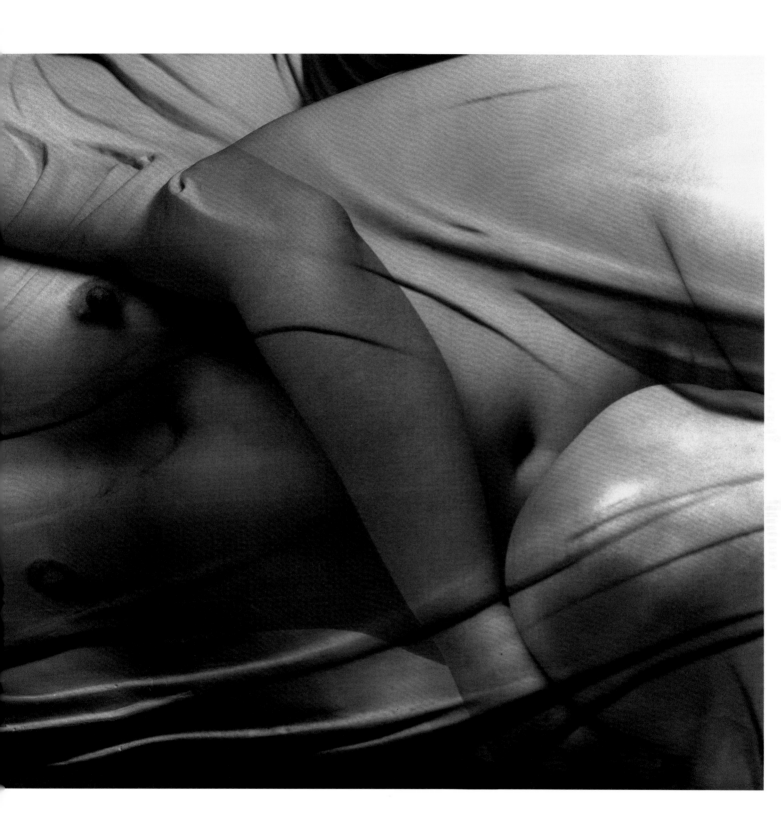

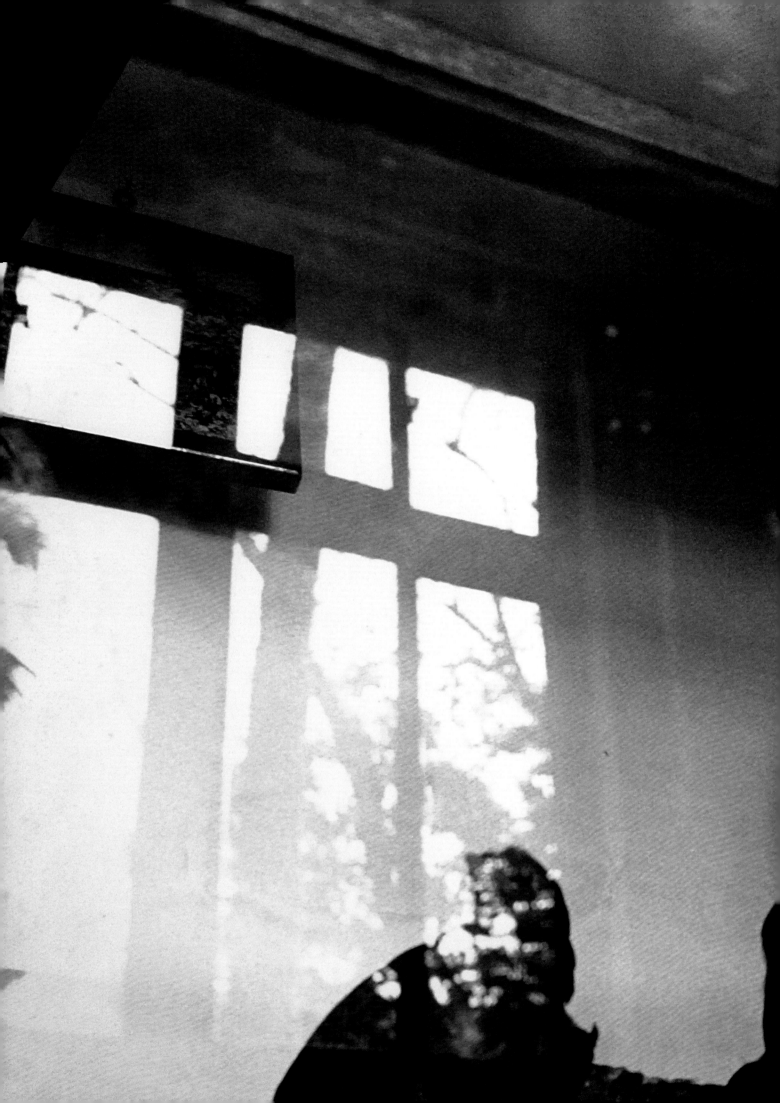

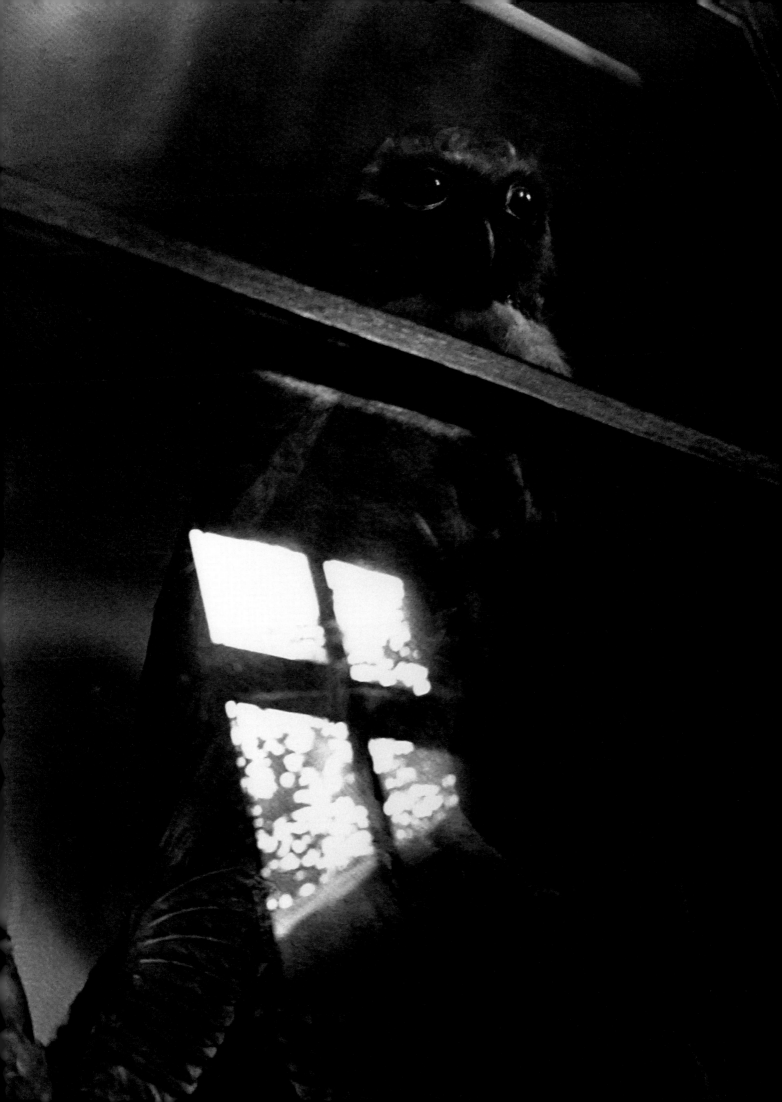

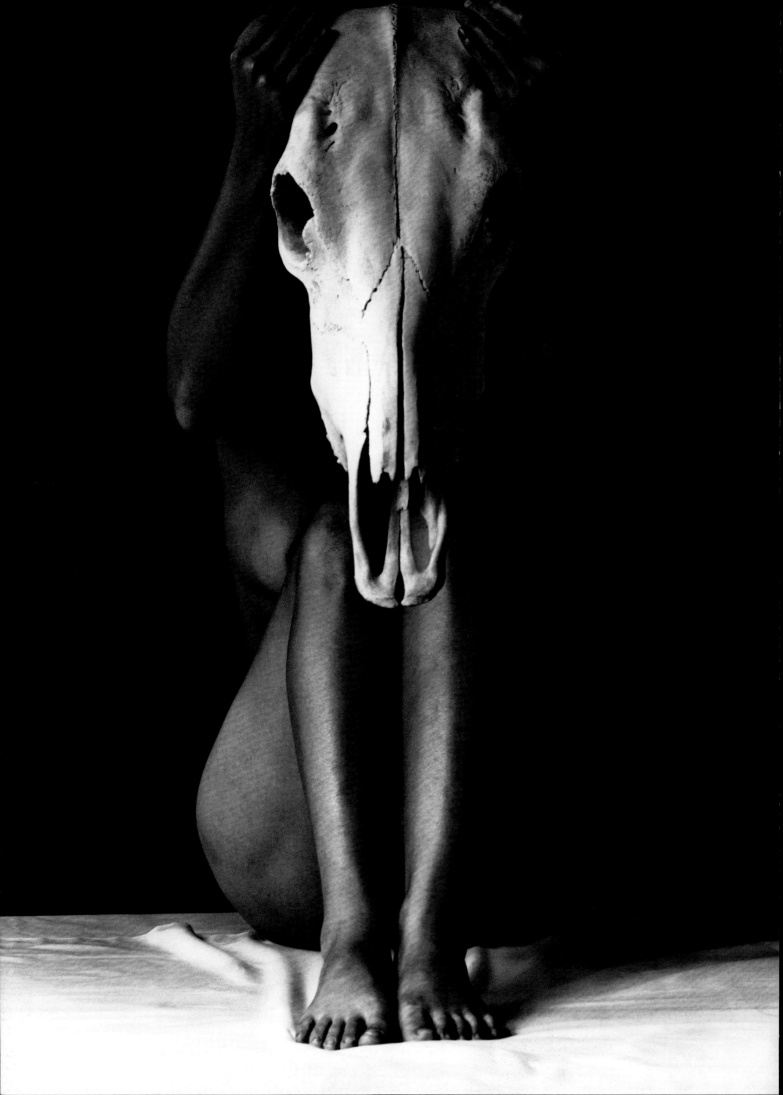

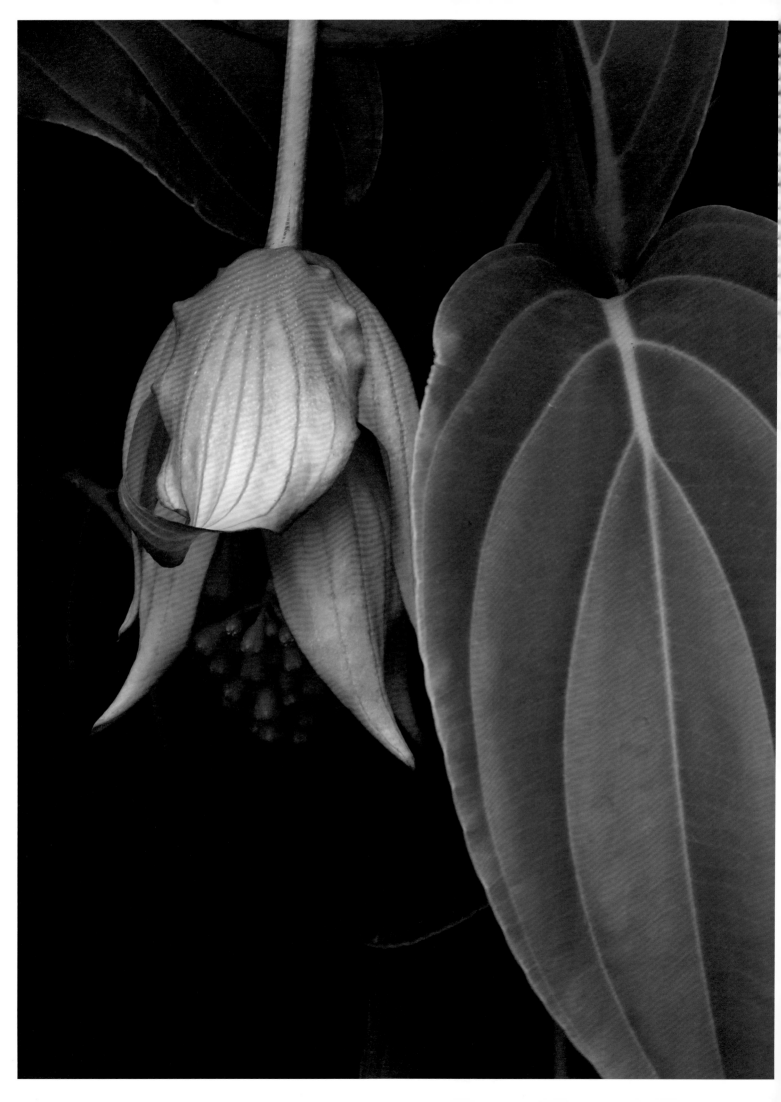

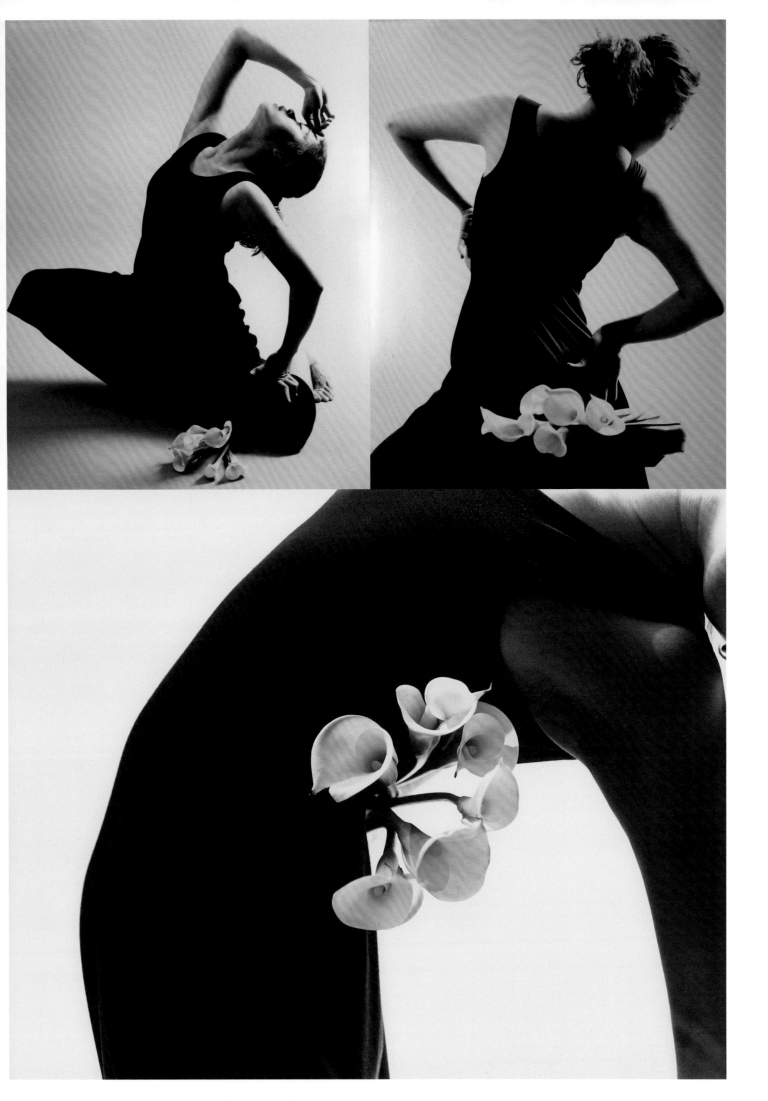

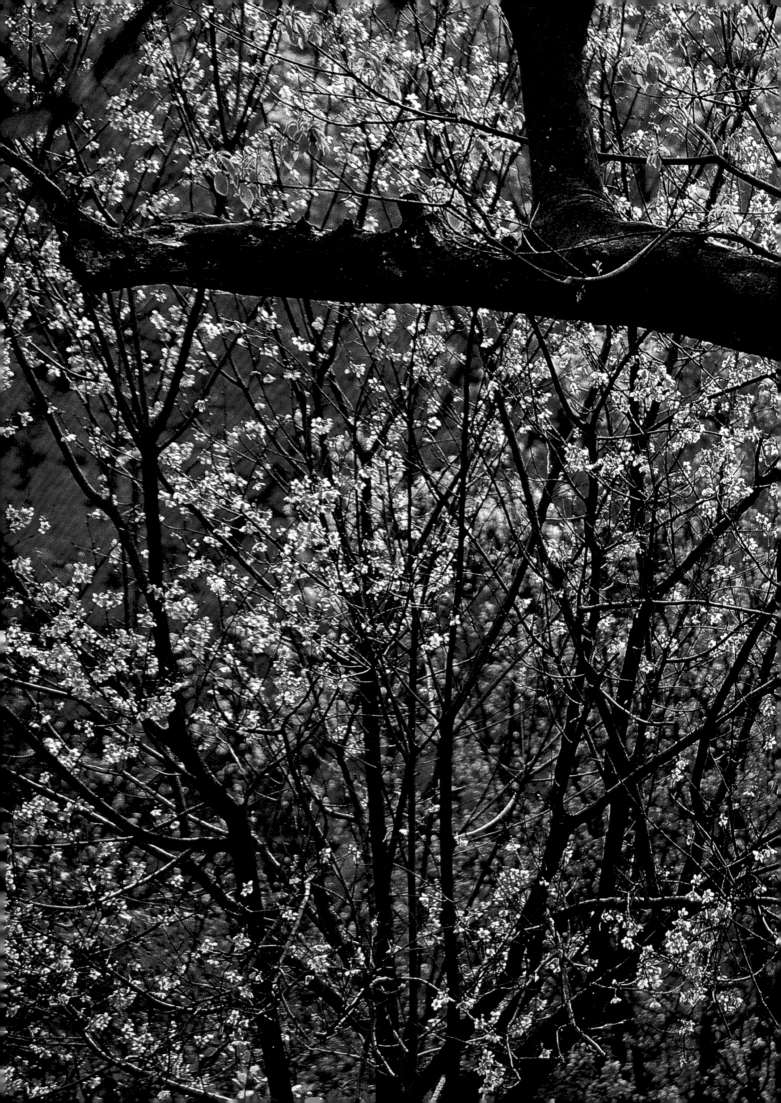

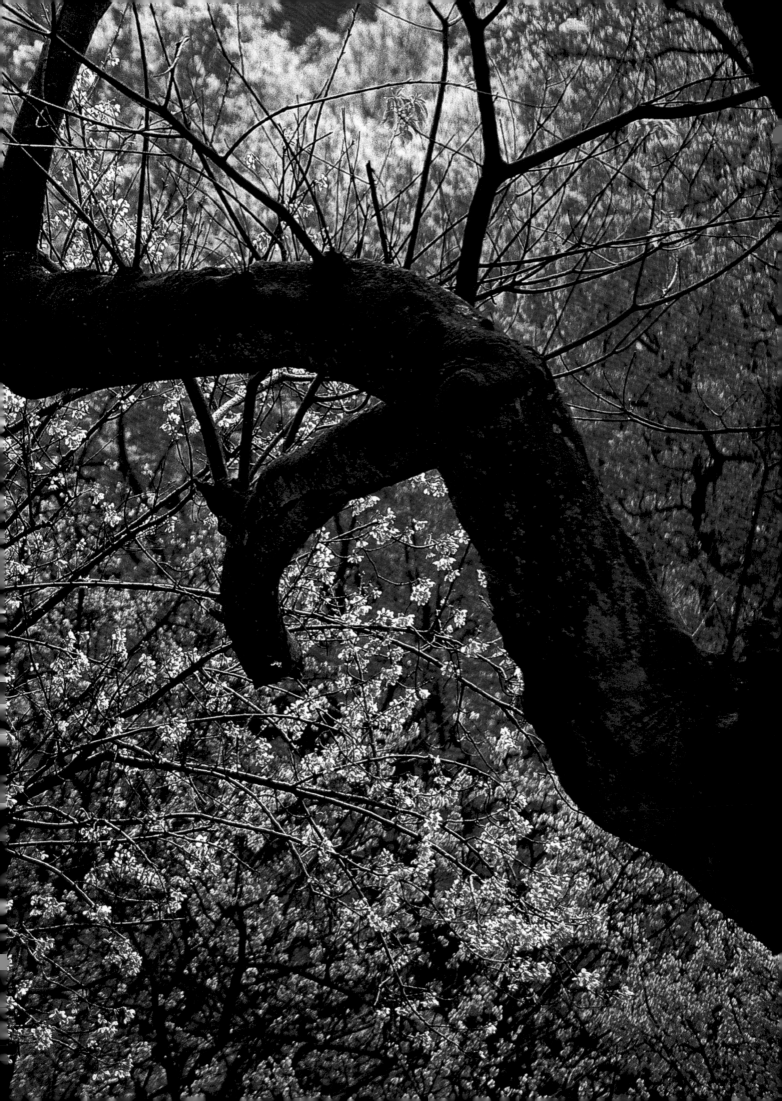

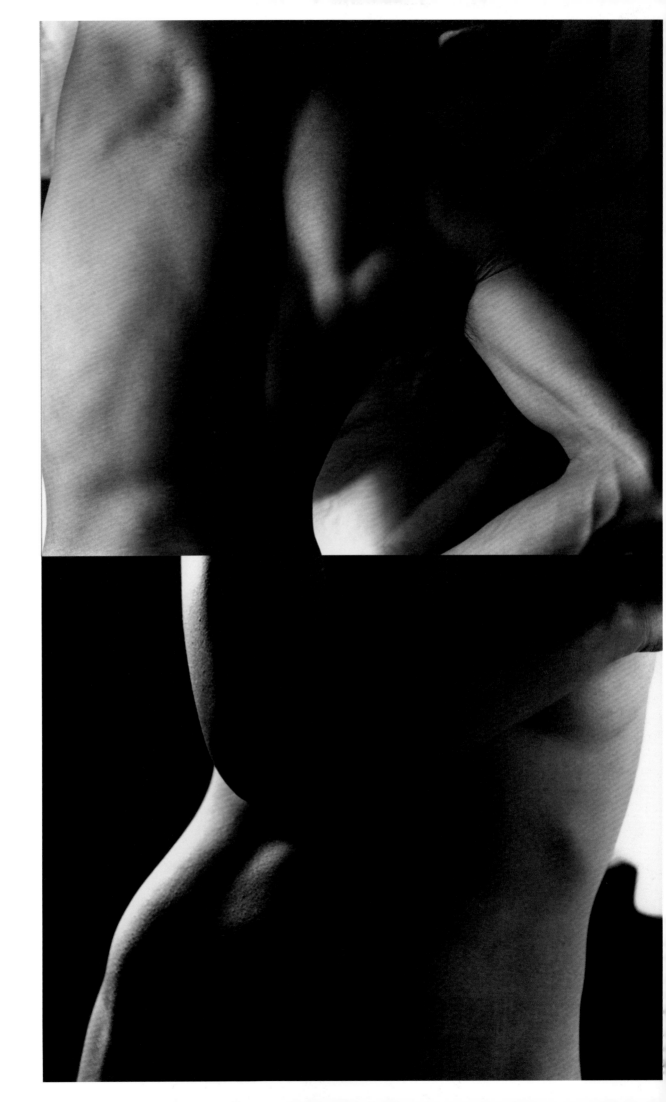

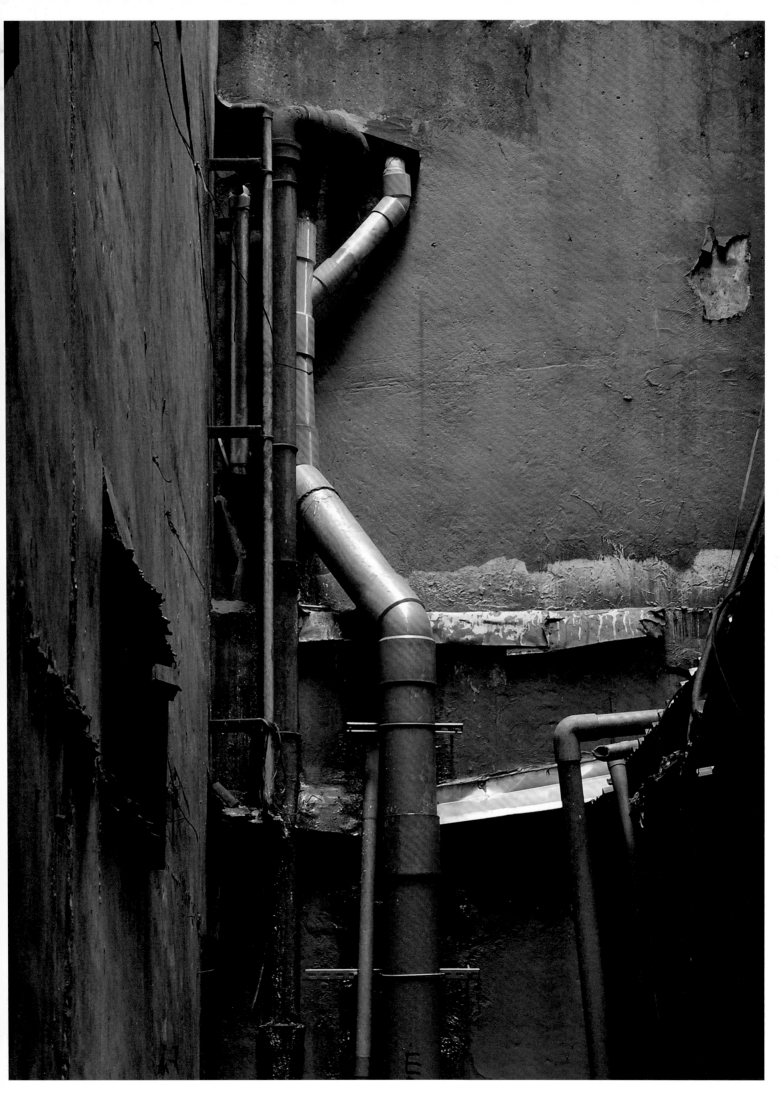

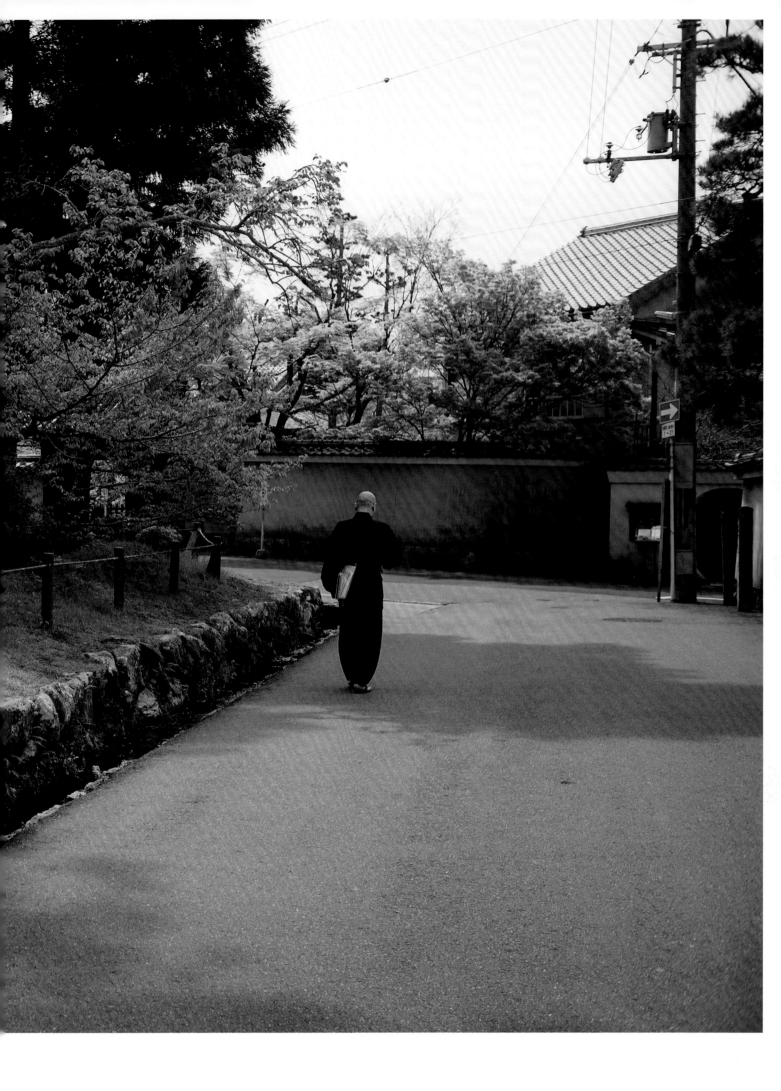

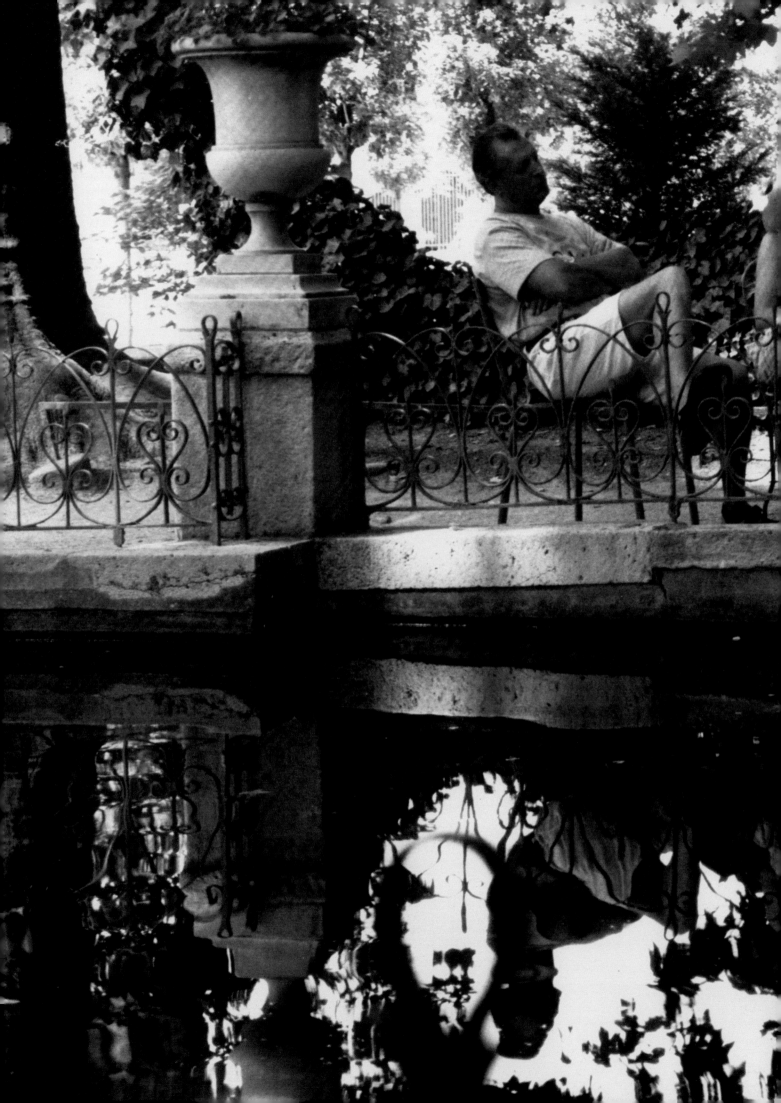

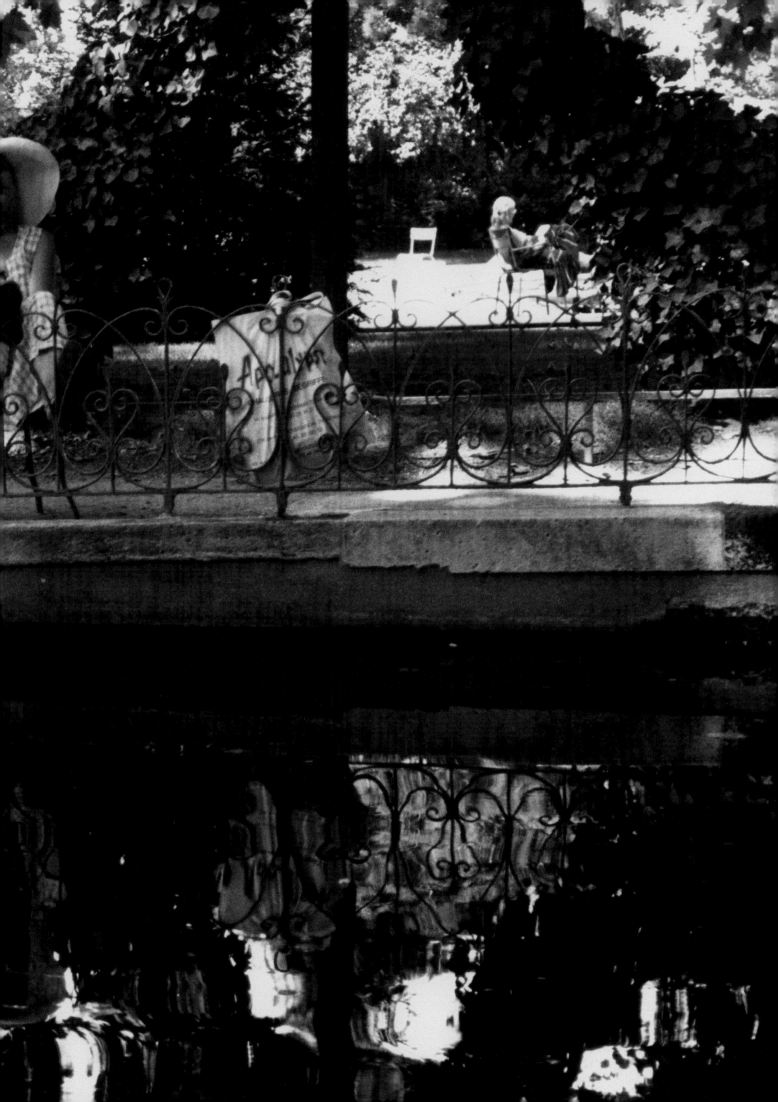

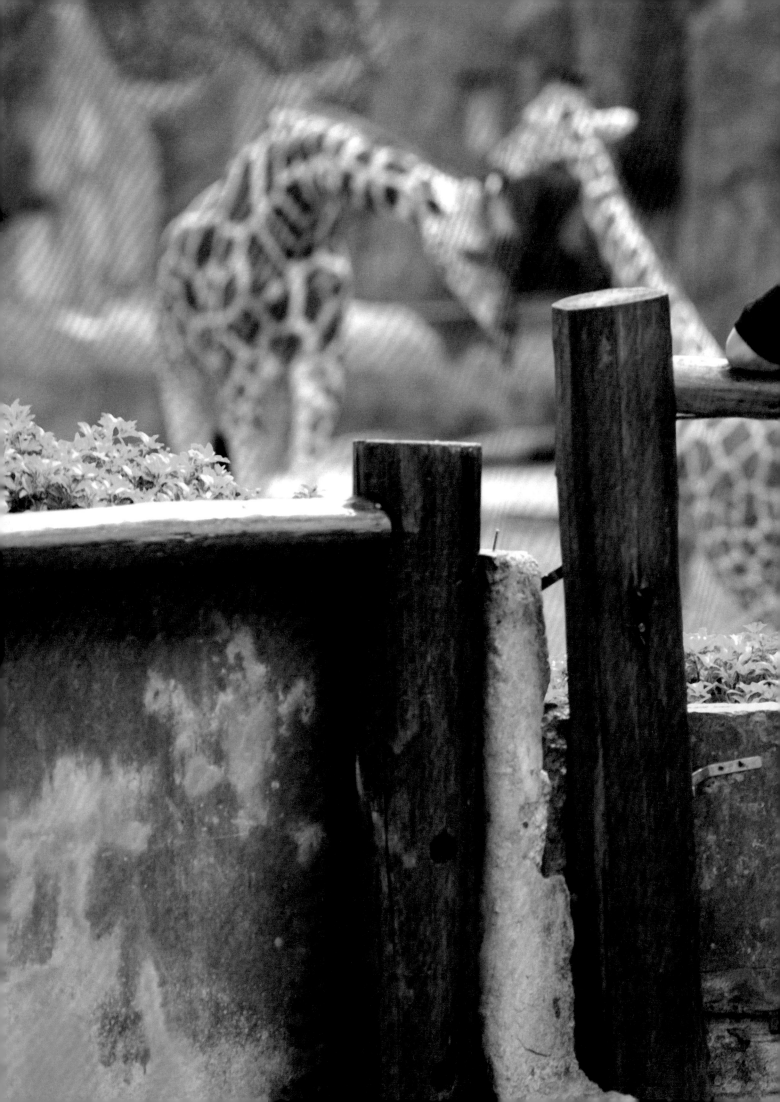

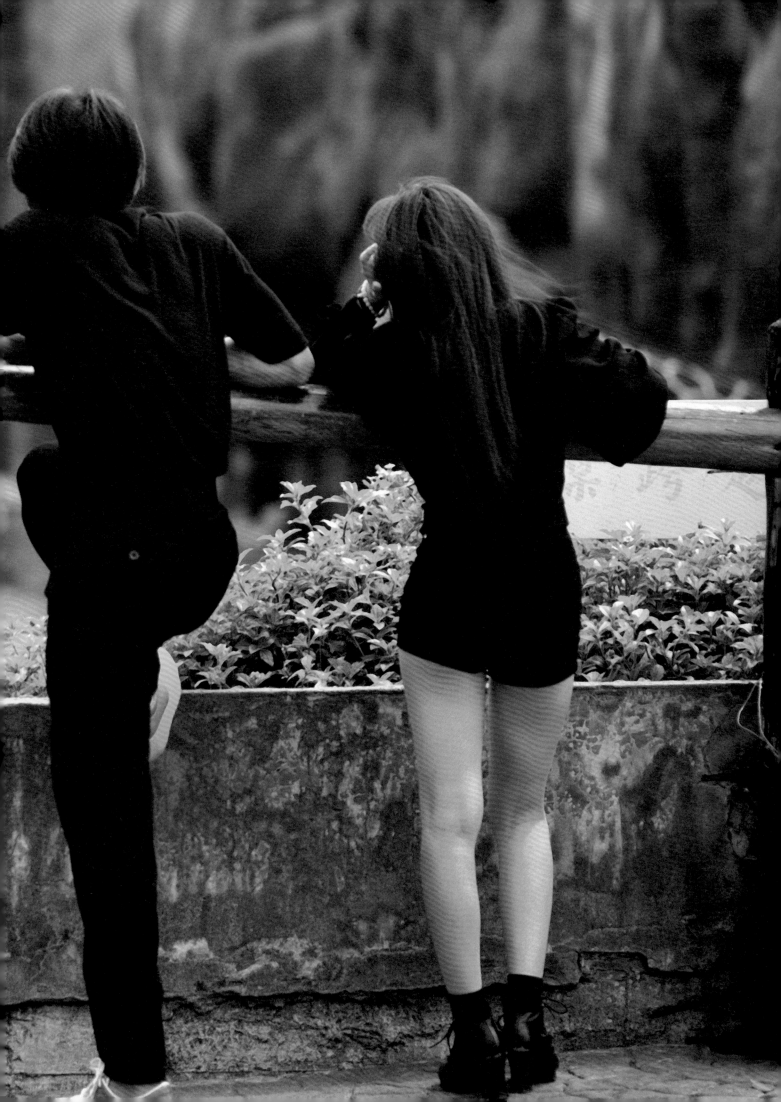

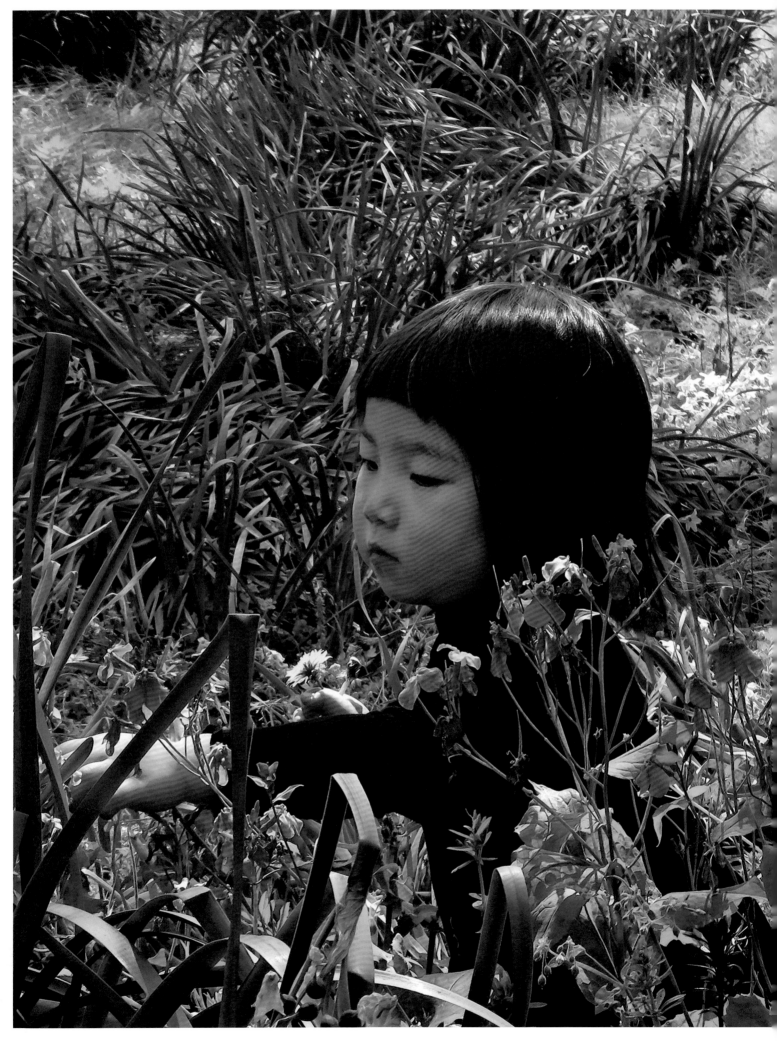

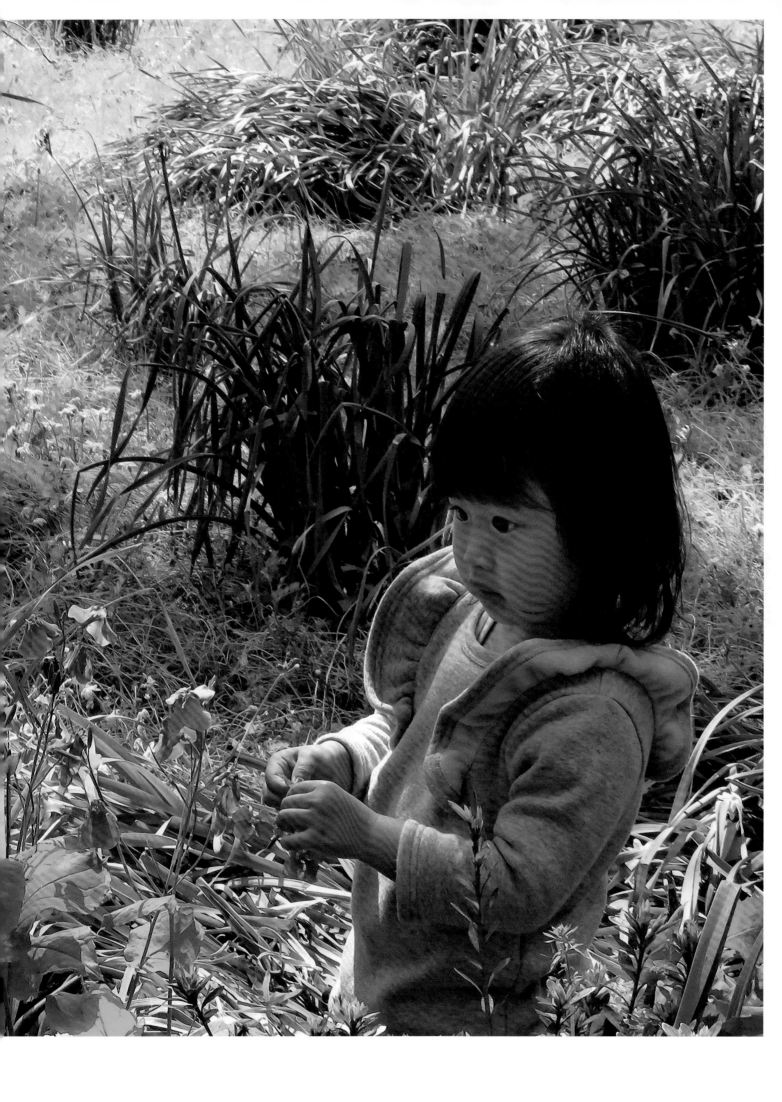

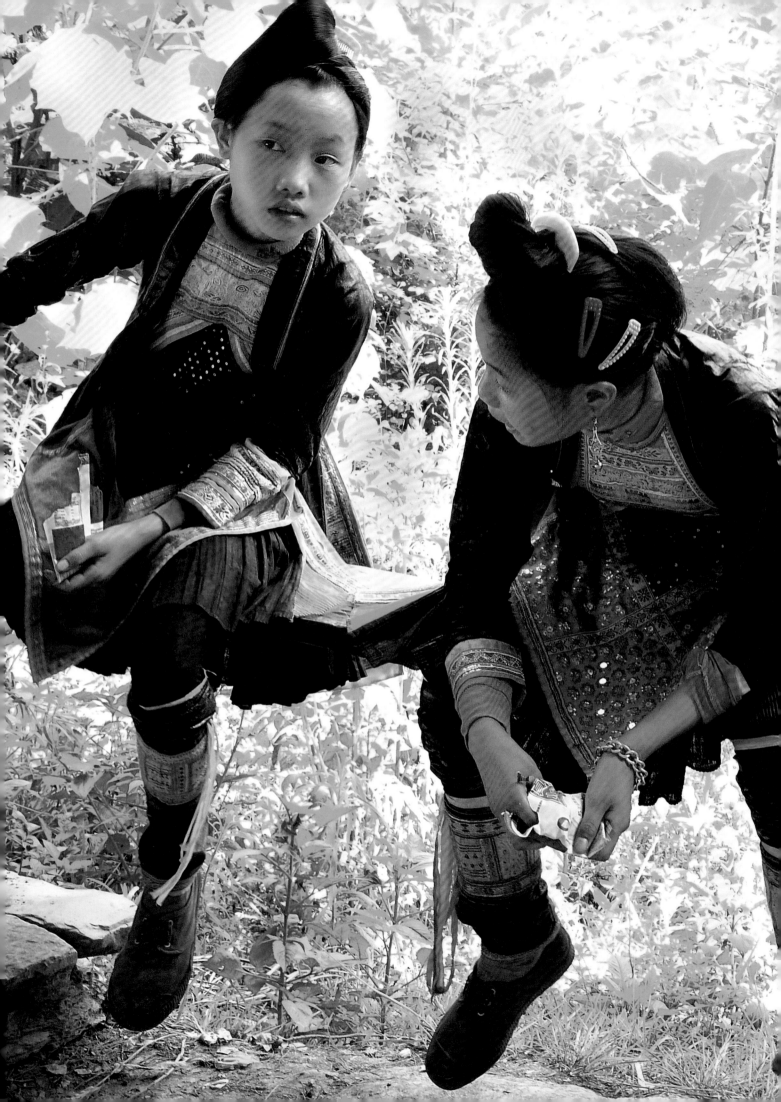

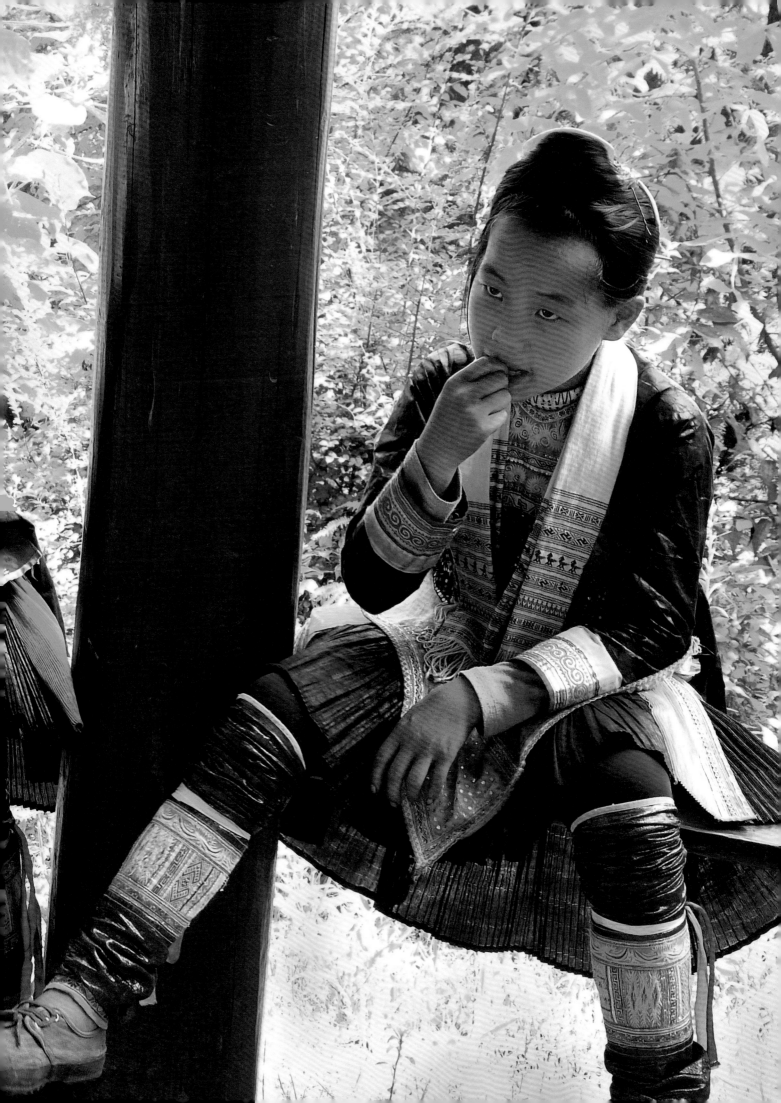

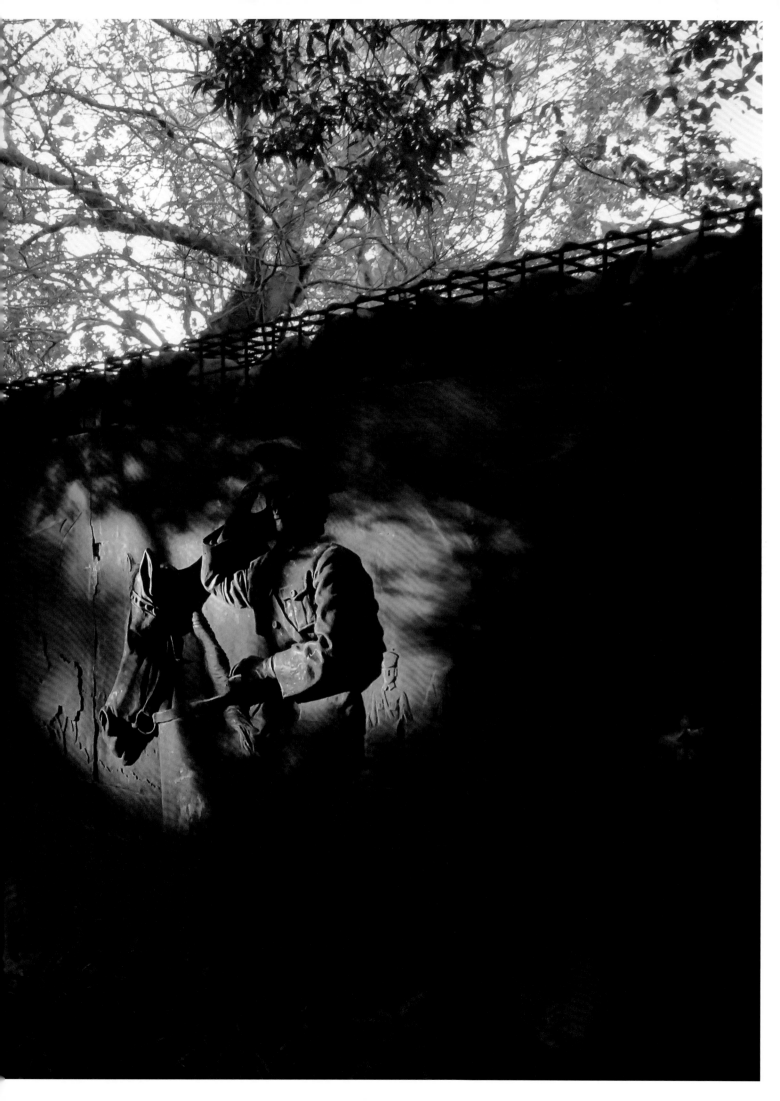

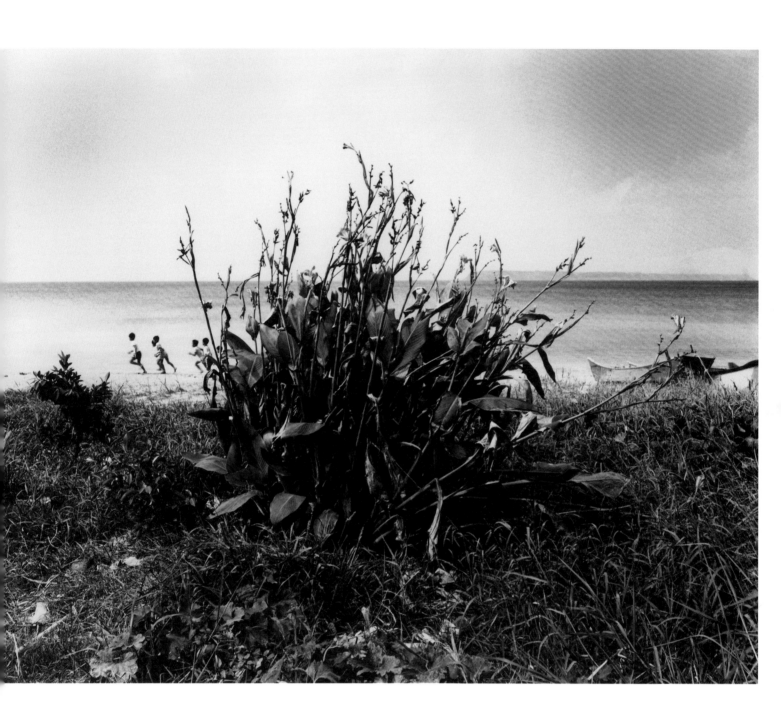

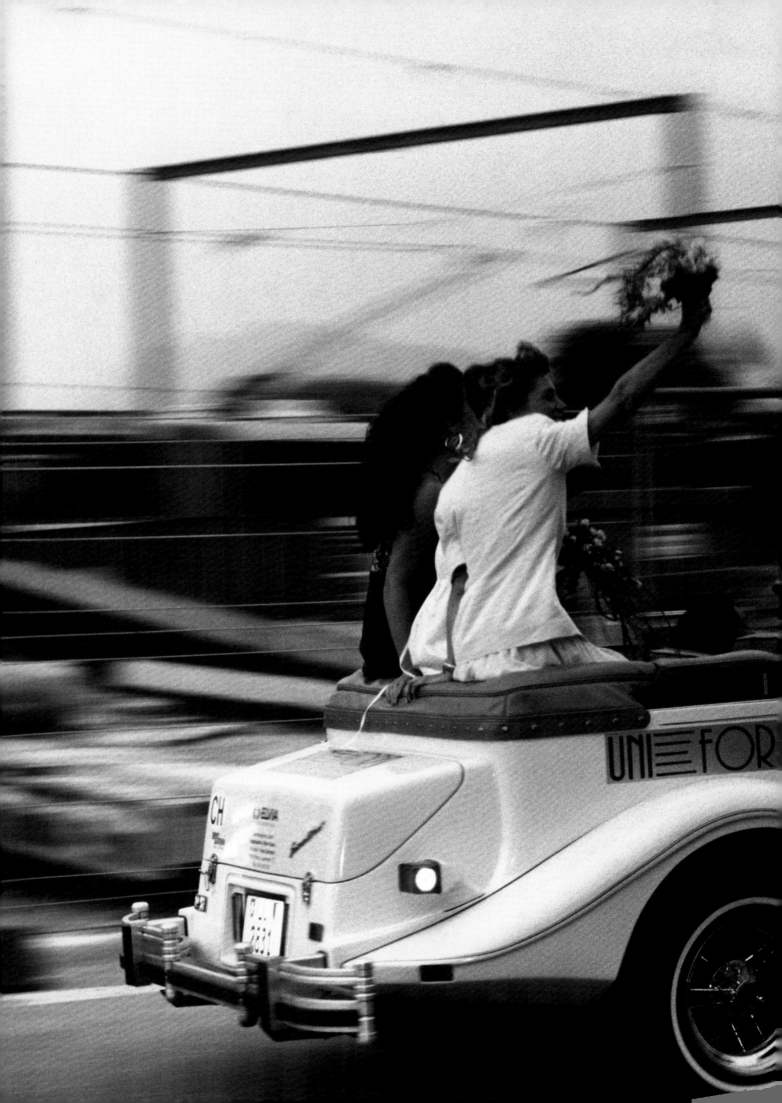

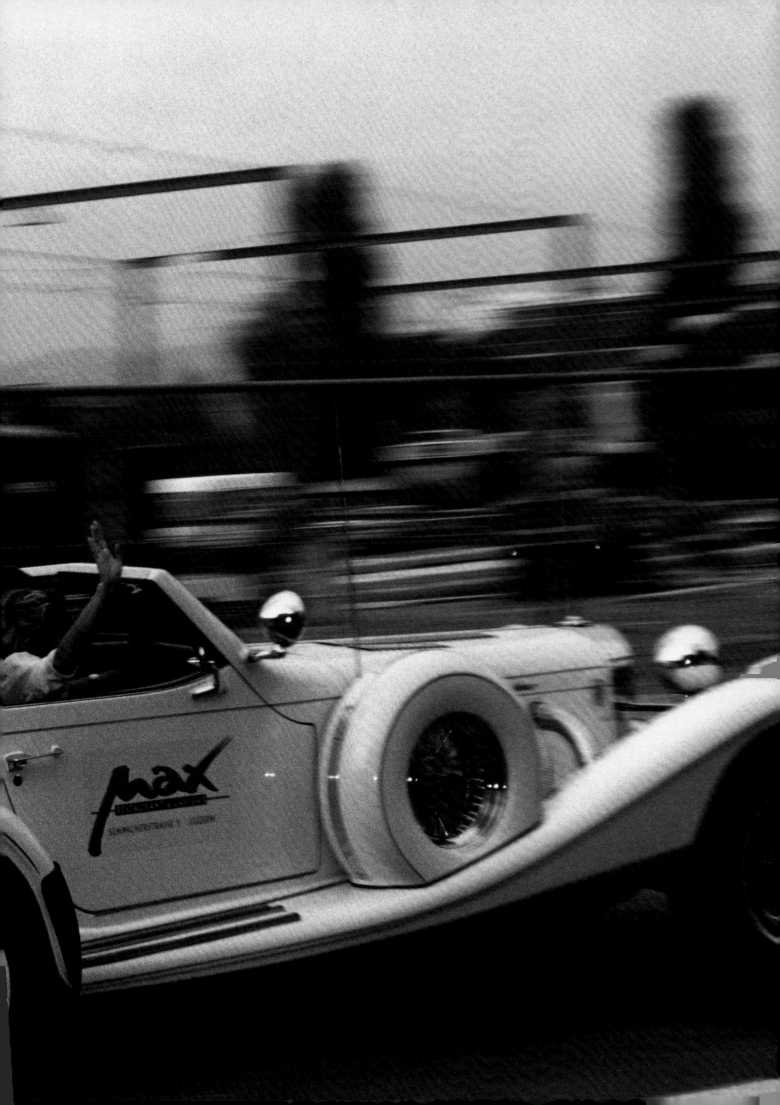

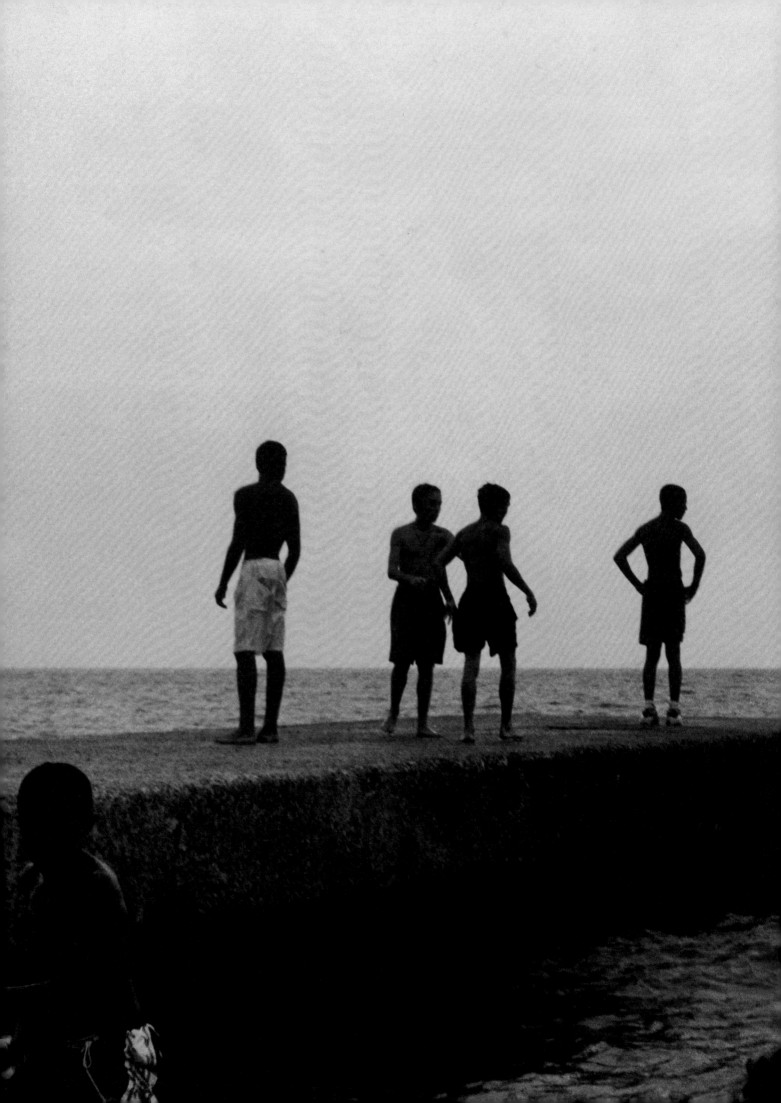

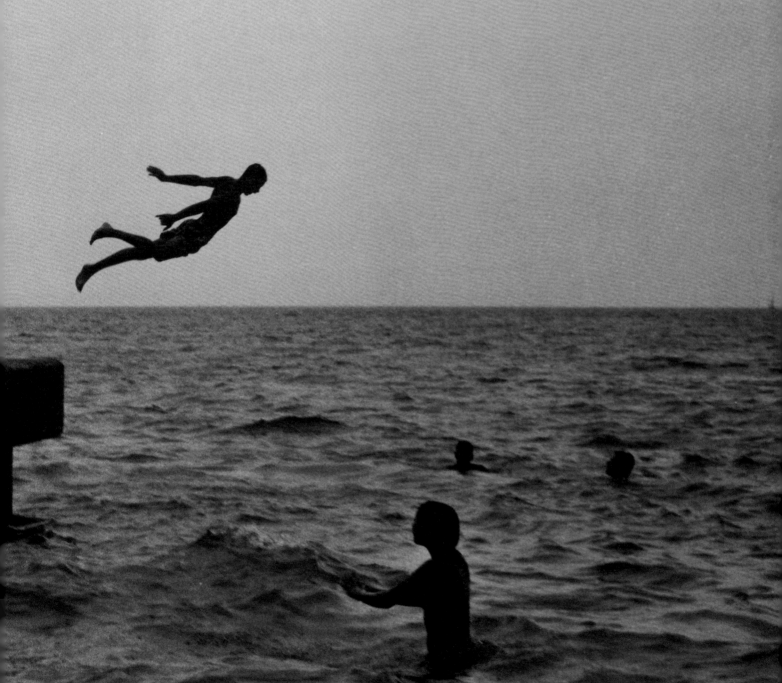

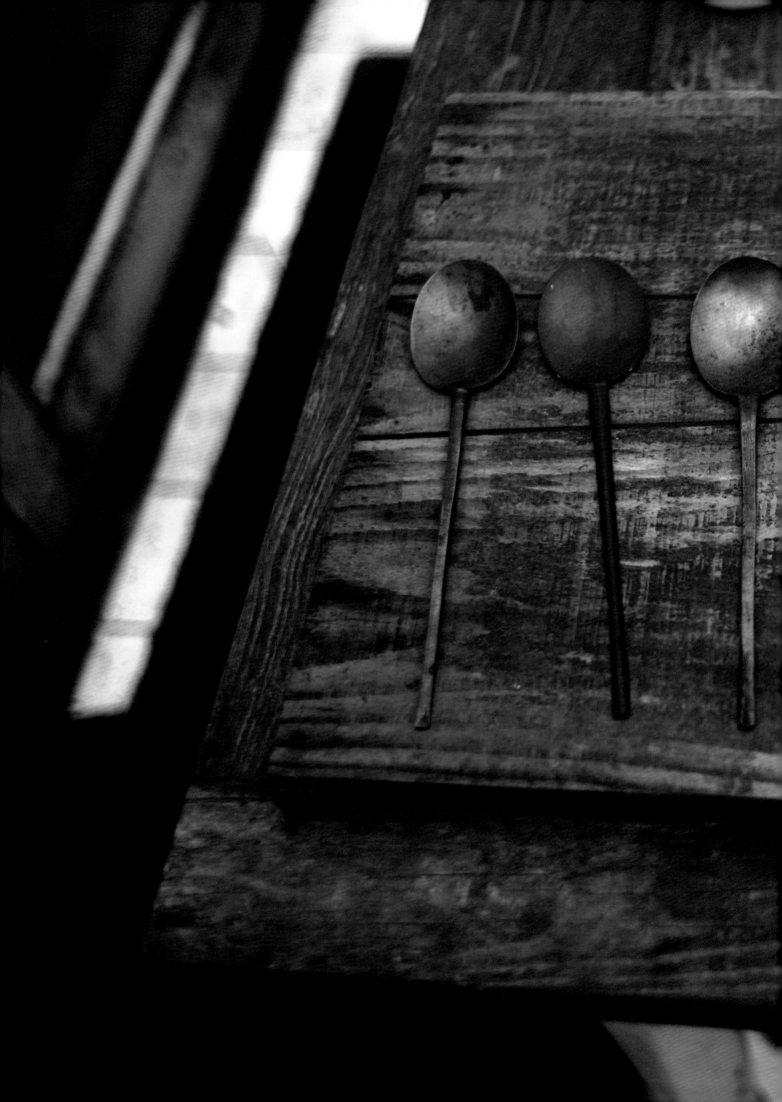

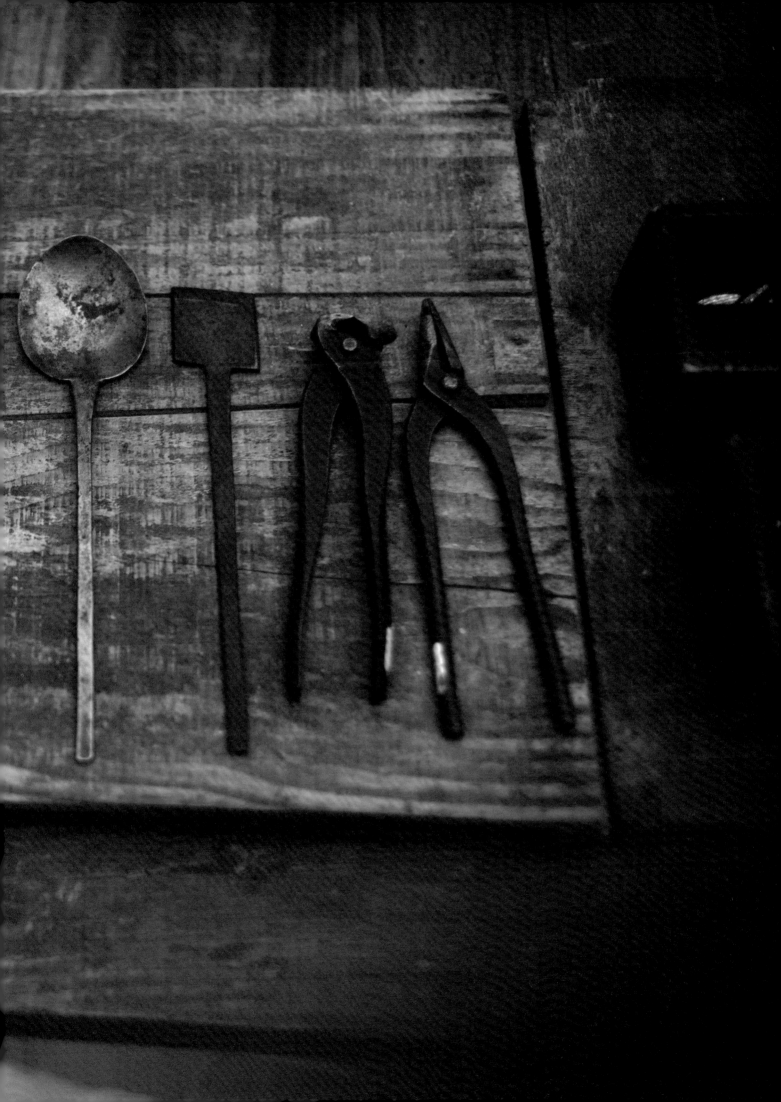

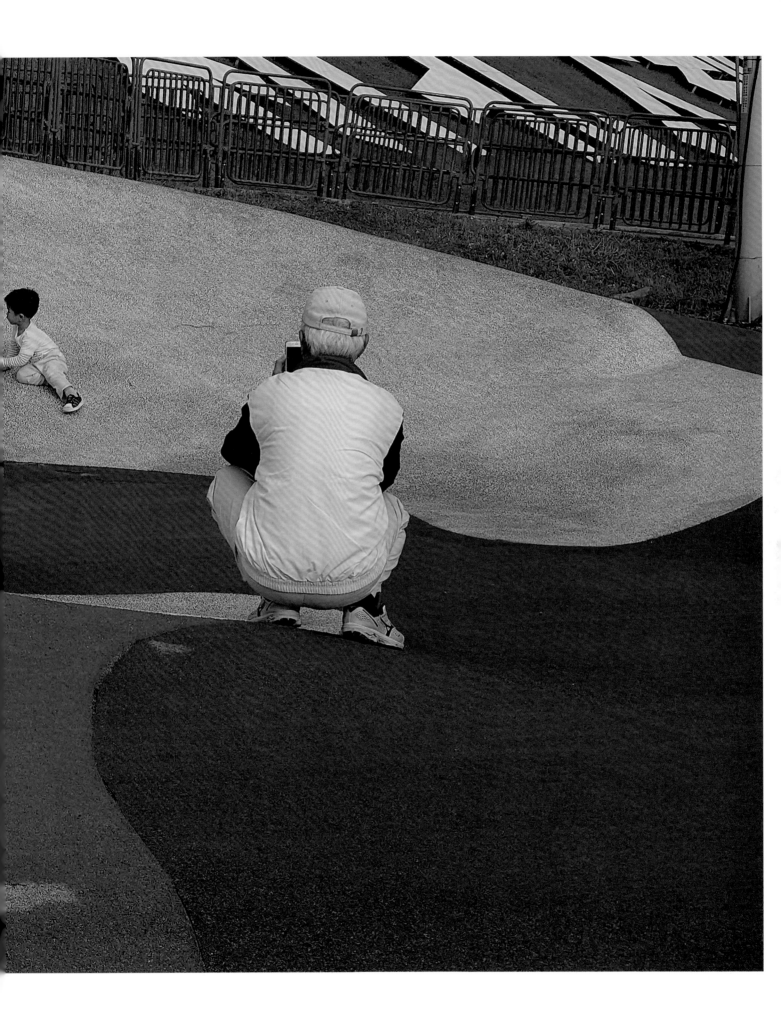

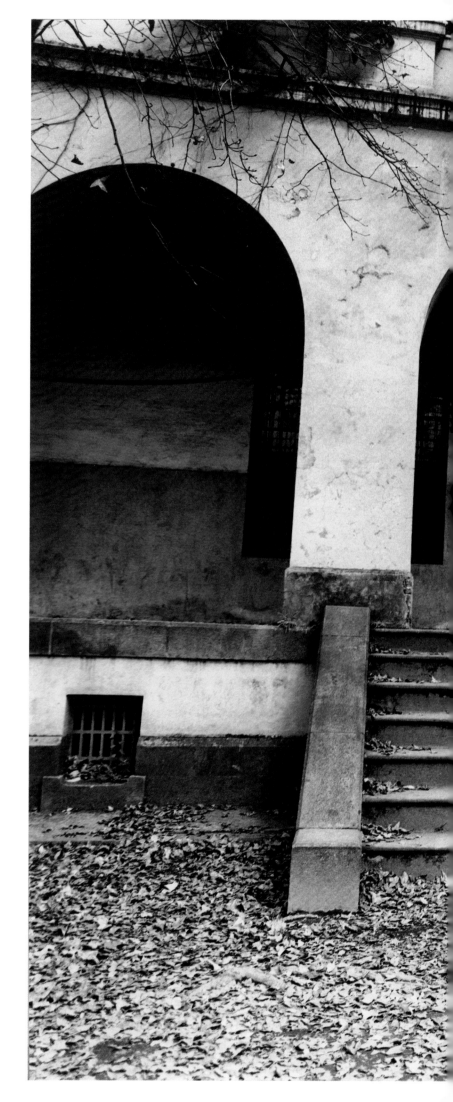

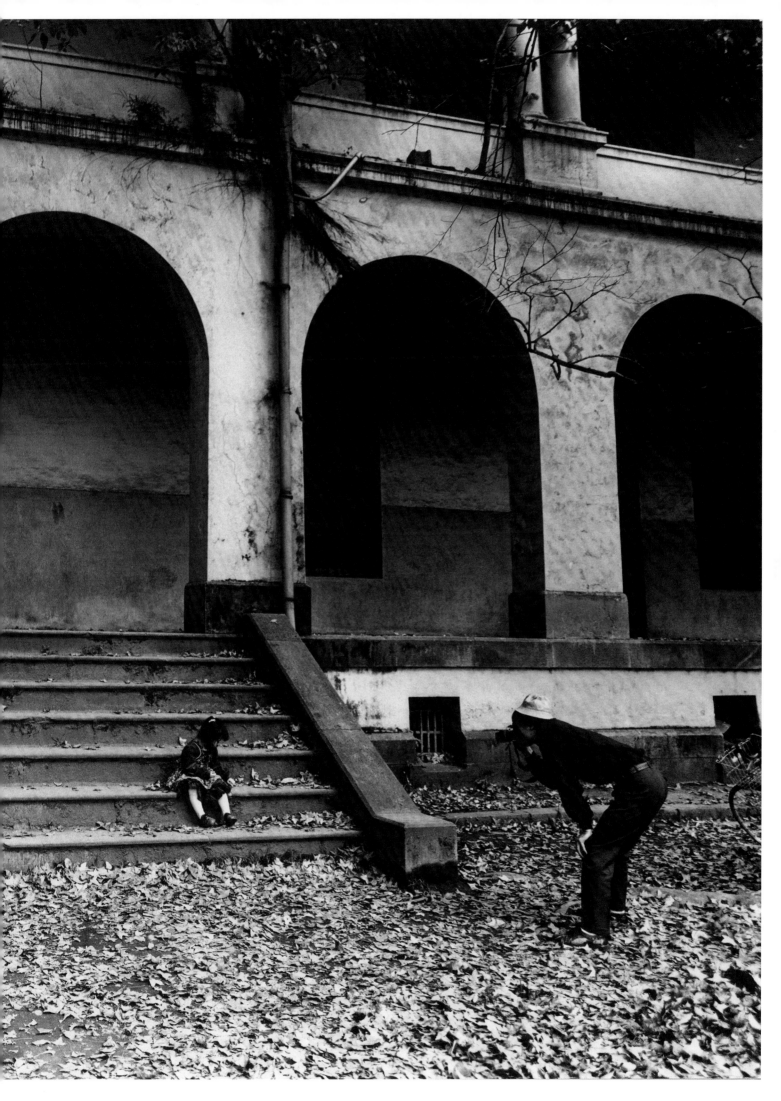

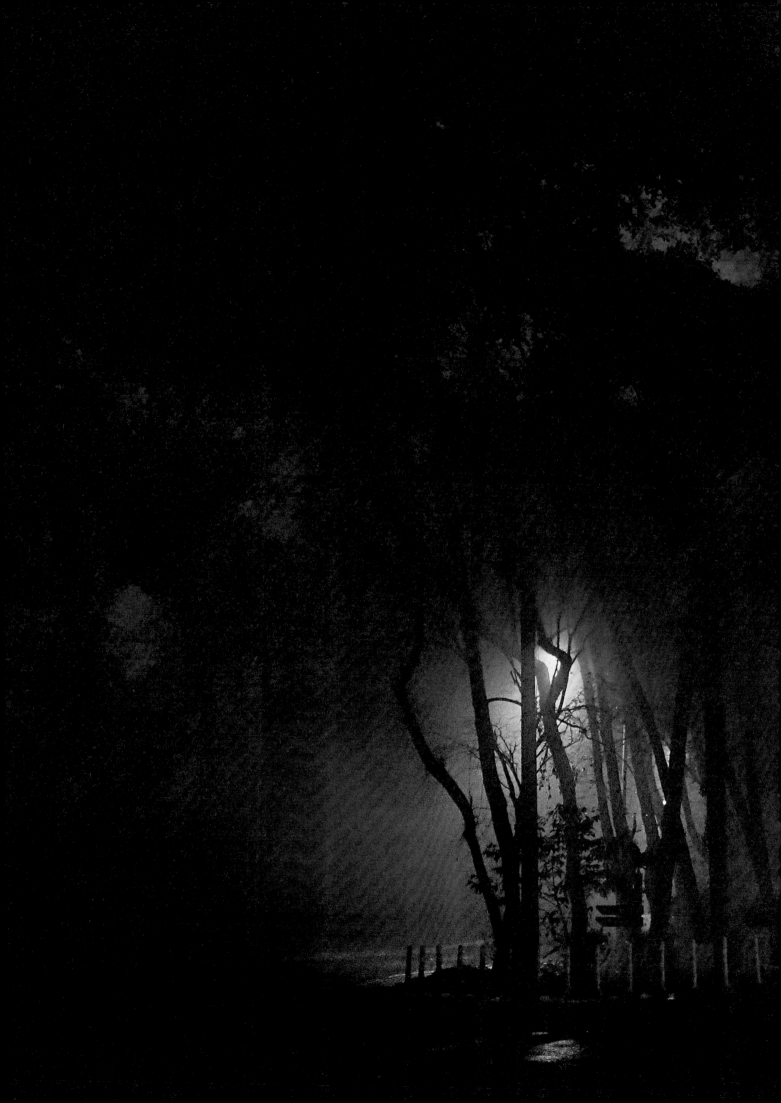

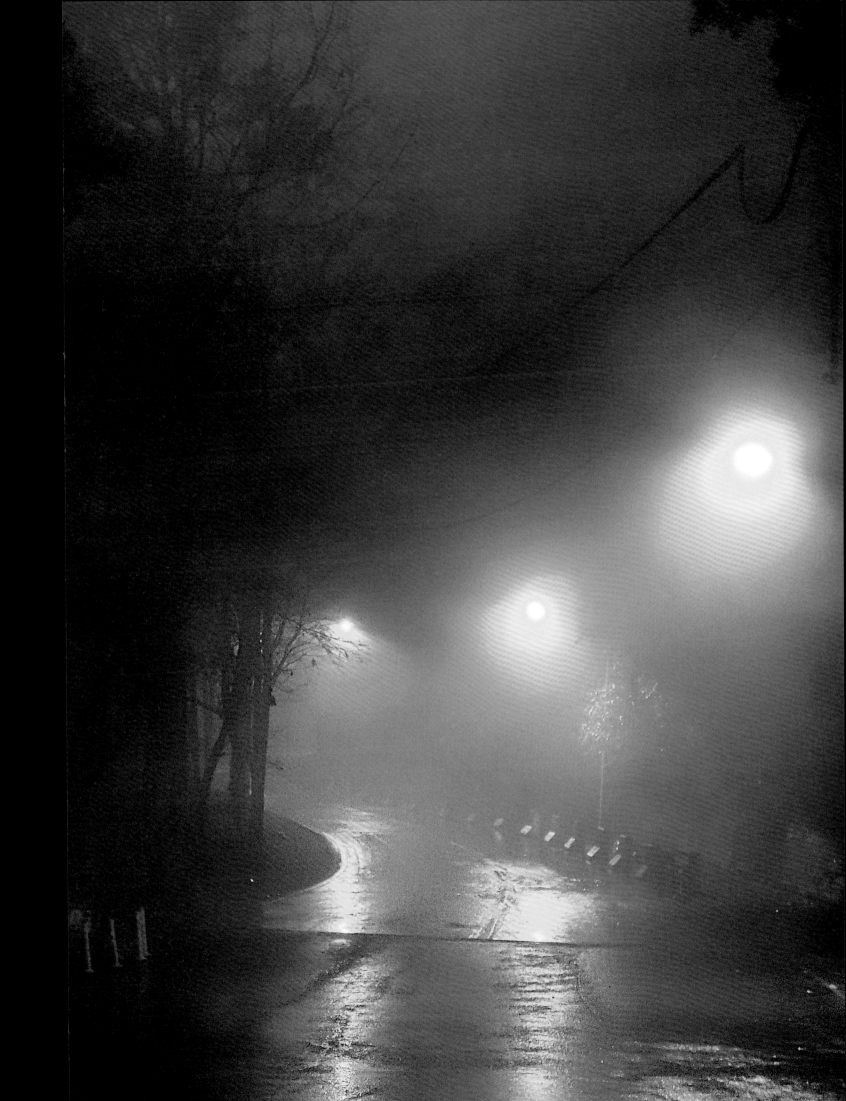

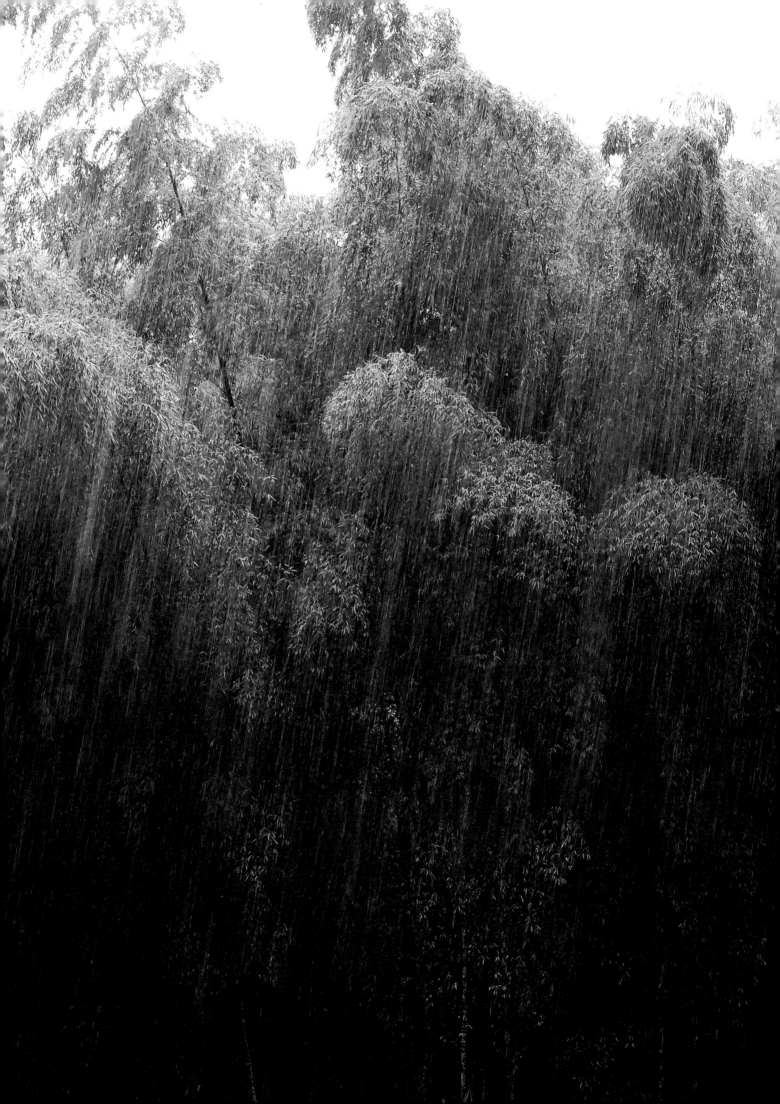

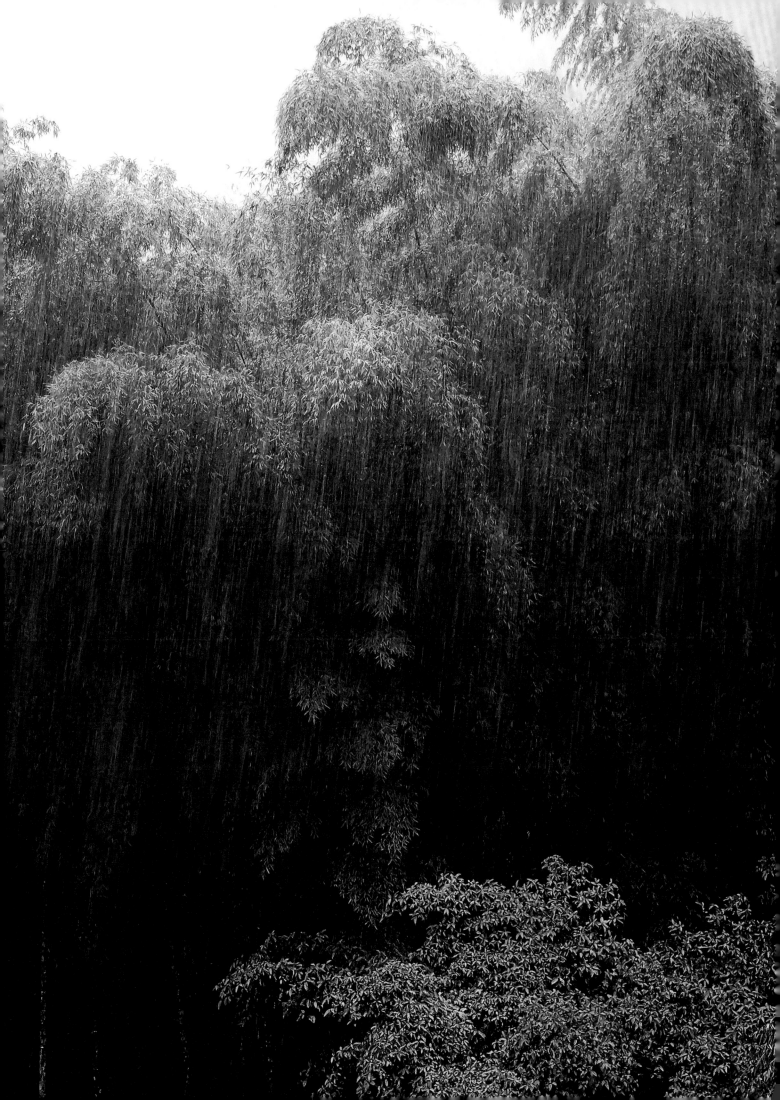

Index

花情　Flower Love

係花的專題攝影，利用景像交錯、對照、重疊、隱喻、想像……
等方式，來傳遞對「花」單純、直接或複雜的感情與印象。

"Flower Love" is the photography series featuring flowers, expressing
the simple, direct, or complicated feelings and impressions on
"flowers" by means of the interlacing, comparison, overlapping,
metaphor, and imagination of the image.

1-1 — 1-2
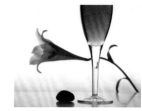

1-3 — 1-4
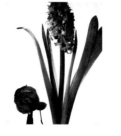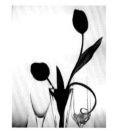

1-5 — 1-6
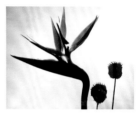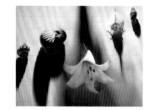

1-7 — 2-1
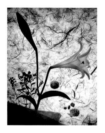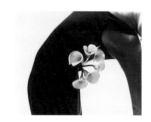

2-2 — 2-3
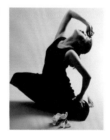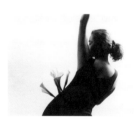

2-4 — 2-5
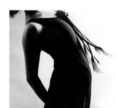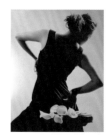

2-6 — 3-1
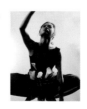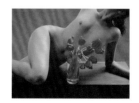

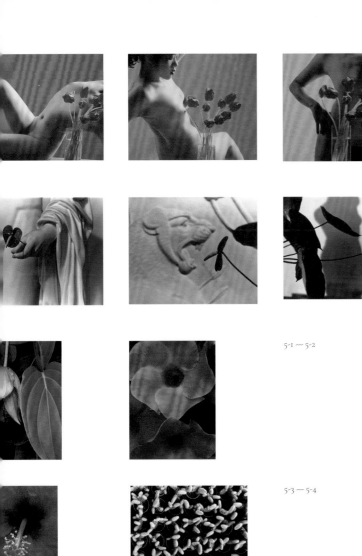

3-2 — 3-3 — 3-4

4-1 — 4-2 — 4-3

5-1 — 5-2

5-3 — 5-4

1 — 2

3 — 4

5 — 6

虛實映象　　Abstract and Concrete Impression

藉偶遇的心情，去發現存在身邊事物，在「虛」與「實」意涵交錯之間，抒發自我獨特美學觀，這是我一直追求的攝影理念。

"Abstract and Concrete Impression" discovers things around through the mood of chance encounter. To express the personal unique aesthetics between the meaning of "abstractness" and "concreteness" is the photographic concept I've been pursuing.

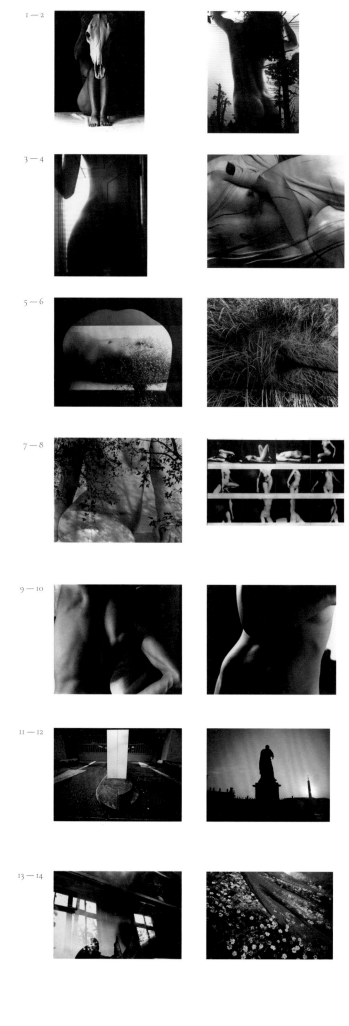

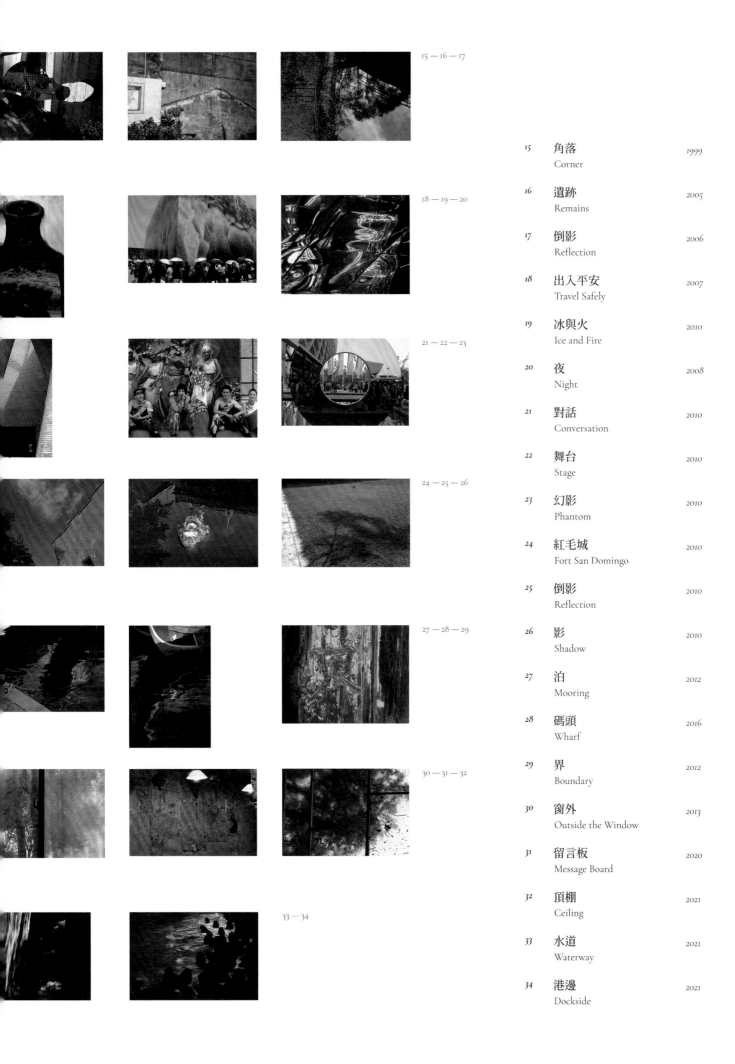

生活符碼 　　　　Life Code

生命之歌，生活之詩，閒適流暢，平易近人。平淡無奇的日常，
常是我眼中的不尋常。

"Life Code" is the song and poetry of life. The leisurely, smooth,
ordinary, and plain daily life is often extraordinary in my eyes.

1 — 2
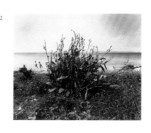
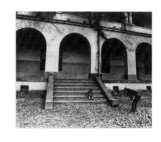

3 — 4

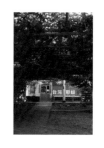

5 — 6
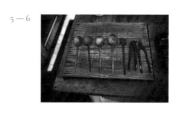
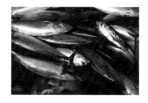

7 — 8
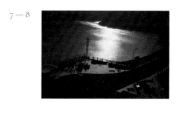
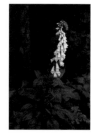

9 — 10
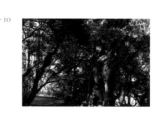
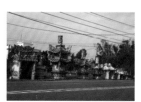

11 — 12
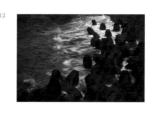
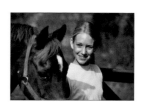

13 — 14
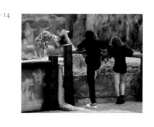

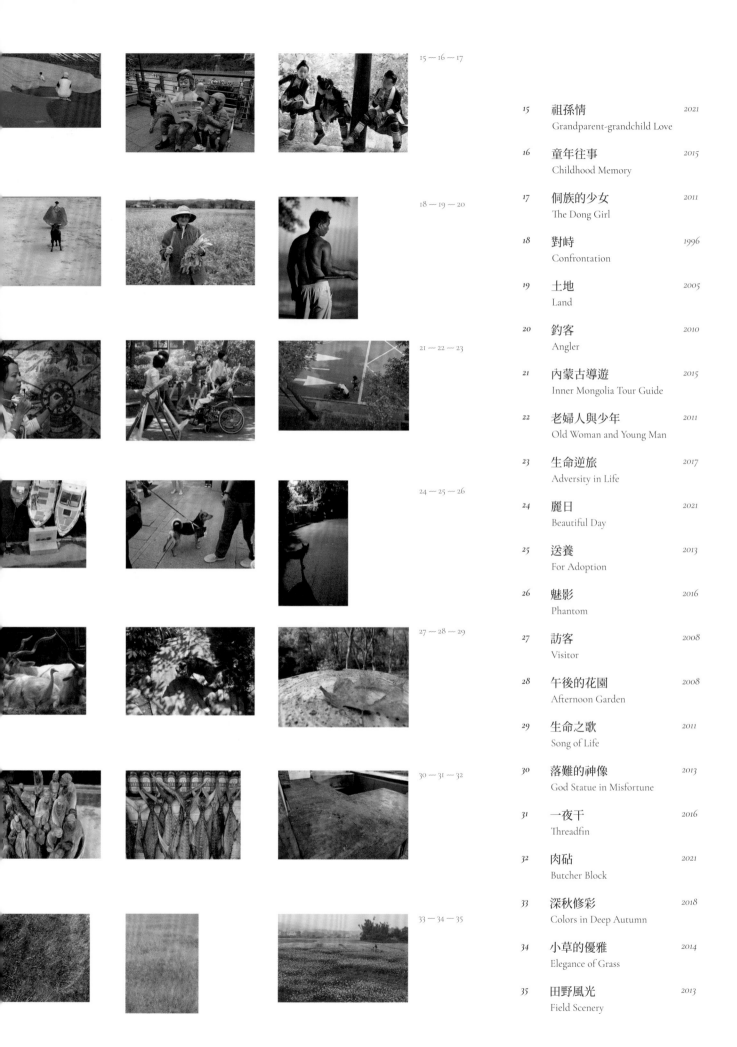

36 — 37
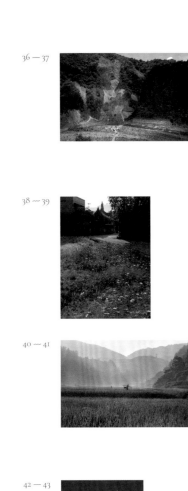

38 — 39
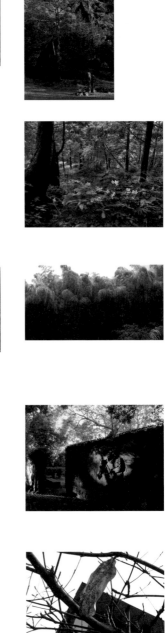

40 — 41

42 — 43

44 — 45
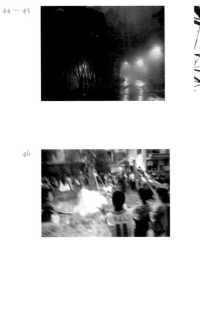

46

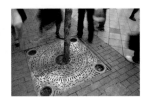
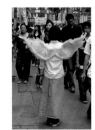

1 — 2

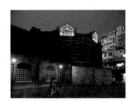
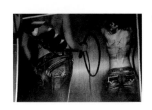

3 — 4

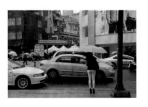
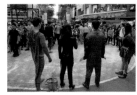

5 — 6

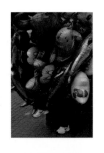
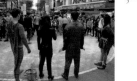

7 — 8

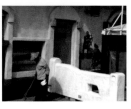
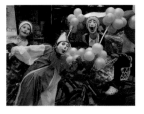
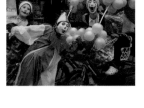

9 — 10

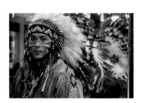
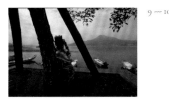

11 — 12

13 — 14

城市定格　　　　Freeze Frame of City

城市像一座舞台，不需編導。跨越紀實與美感，作品是傳遞超越景物以外的想像。

In "Freeze Frame of City," a city is like a stage without choreography covering documentation and aesthetics. The works convey the imagination beyond scenery.

15 — 16

17 — 18

19 — 20

21 — 22

23 — 24

25 — 26

27 — 28

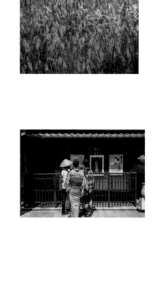

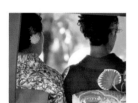

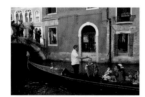

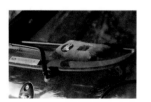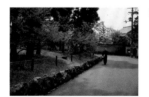

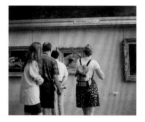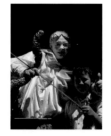

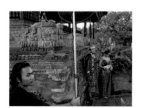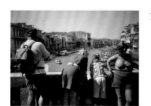

Monograph
&
urriculum Vitae

心之所向

Heart's Desire

法國巴黎第一萬神殿索邦大學藝術學博士

Ph.D., Paris I Panthéon-Sorbonne University, France

孫維瑄

Sun Wei-shiuan

Refinement & Reflection

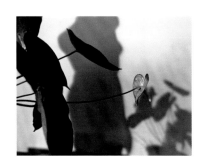

回顧展一般而言是功成名就的象徵與經典的回憶。然而,細數著四十多年的藝術生涯,康台生正帶著睿智與熱情的眼神訴說著一個嶄新創作的開端!

誠如其自述:「藝術創作對我而言是生活的淬鍊和省思。」他的人生歷程也與藝術演變和昇華密不可分且相輔相成。因此本次展覽的影像並非以時序性而是以專題系列方式呈現,試圖探究每個主題在不同創作階段的成長與意義。藝術家展現的是一種謙和與智慧的態度,在當下的時空將以往的創作和未來的盼望紛然並呈。

康台生令人感佩的不僅是在教育界的輝煌成就,更重要的是他將學術環境的任務和挑戰視爲建構創作學理的磐石與實現理念的動力,將展覽與策展視爲建構藝術創作系列以及國際交流的契機。

康台生在藝術教育的卓越成就受人敬重,長久以來勤懇地耕耘,厚實了台灣攝影藝術教育的沃土,也淬鍊出自我深厚又多元的藝術表現形式。而平時隱藏在鏡頭後的赤子之心以及愛好自由與大自然的靈魂,則不時在創作時眞情流露。

攝影對康台生而言,與其說是一種記錄,不如說是一種「看法」,一種宏觀於表象之外,或者微觀於萬物之中的觀看,可以是長時間的入微觀察,抑或是轉瞬間的驚鴻一瞥。

以展覽爲契機,審視和精選早期作品和近年尚未發表的新作。呈現長時間的系列創作,如持續 30 年以上的《城市定格》與《生活符碼》,同時融入展現意到鏡隨與時代感的手機組曲影像日記等,層層強化展覽的整體概念。

展覽內容以四大主題呈現:《虛實映像》、《花情》、《城市定格》與《生活符碼》,猶如生命樂章四大曲式的起承轉合。以作品的敘事性意涵爲主旋律,譜寫出抒情浪漫、優美溫暖、詼諧歡快或磅礡震撼的形式風格。每幀影像都是創作的元素、敘事的符碼及詠歎大自然的音符。

《花情》系列,以 1993 年與 2015 年兩個創作階段爲主,對照出早期與後期創作風格與心態的轉變。九〇年代正值台灣攝影藝術化與學術化風潮,康台生爲符合當時學術氛圍與升等要求,融合嚴謹的學術研究態度與實驗精神,鑽研攝影棚拍攝與暗房的技巧與美學。爲了建構攝影專題與學術專論,他不僅追求技法的純熟,更營造超現實的情境。他擅用精緻的光影雕塑出典雅簡練的造型,運用影像特寫、留白、交錯、重疊與隱喻等技法,表達花的姿態、對花的聯想與情感,或藉由花的特質和其他元素的互動來象徵七情六慾和生命百態。主題性的研究和創作以及豐富的攝影美學建構讓他順利取得教授資格並留下珍貴的影像記錄。(圖例:「4-3 聯想系列」1993)

A retrospective exhibition is generally the symbol of great achievement and the recall of classics. However, in the retrospective of his art career of more than forty years, Kang Tai-sen is telling a fresh start of creation with wisdom and passion in his eyes!

As he said: "For me, art creation is the refinement and reflection of life." His life experience and art transformation and elevation are closely related and mutually supportive. Therefore, the images of the exhibition are not arranged in chronological order but series, attempting to study the growth and meaning of each topic in the different creative stages. The artist shows a humble and wise attitude and presents the past creation and future expectations together in the present time and space.

The most admirable is not only Kang's splendid achievement in the education circle. More importantly, he regards the missions and challenges in the academic environment as the cornerstone to constructing the creative theories and the energy to practice concepts. For him, holding and curating exhibitions is the best chance to construct a series of art creations and international exchange.

Kang's outstanding achievement in art education is respected. His long-term diligent cultivation consolidates the fertile land of photography and art education in Taiwan and refines into the personal solid and diverse artistic expressions. The innocent heart and the soul that loves freedom and nature are frequently revealed in creation.

For Kang, photography is not so much to record as to express "opinions," the macrocosm outside the appearance or the microcosm inside all things. It can be the long-term careful observation or a transient glimpse.

Through the exhibitions, he examines and selects the early works and the unpublished new works in recent years, presenting the series of works of a long period. For example, the series over thirty years, "Freeze Frame of City" and "Life Code," include the smartphone suite, the image diary that captures the instant images and a sense of time with phones, to reinforce the overall concept of the exhibition.

The exhibition is categorized into four major topics: "Abstract and Concrete Impression," "Flower Love," "Freeze Frame of City," and "Life Code," like the different music forms of the life chapters. The narrative meanings of the works as the main themes compose the lyrical, romantic, beautiful, warm, joyful, or magnificent styles. Every image is the creative element, narrative code, and nature-praising note.

In the series of "Flower Love," there are two major creative stages. The years 1993 and the year of 2015 contrast the early and late periods in terms of the transformation of style and mind. In the 90s, photography in Taiwan became more artistic and academic. To correspond to the academic atmosphere and meet the promotion requirement, he integrated the strict academic research attitude and experimental spirit and studied the techniques and aesthetics of studio shooting and darkroom. To construct the photographic projects and academic papers, he not only pursued skillful techniques but also created a surreal atmosphere. He excelled at sculpturing the elegant and simple styles with the exquisite light and shadow, representing the appearance of flowers and the association and feeling for flowers by applying close-up images, blank space, interlacing, overlapping, and metaphor, or symbolizing men's emotions and desire and all aspects of life with the interaction between the features of flowers and other elements. Through the thematic research and creation and the various construction of photography aesthetics, he successfully secured the post of professor and left the precious image record. (Picture: "4-3 Association Series" 1993)

淬鍊 · 省思

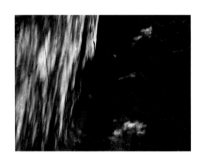

而到了近期，康台生的花往往沐浴在自然光之下，他喜歡在自然環境中細微地觀察植物的生活狀態，希望呈現出大千世界的生命循環與自然風貌。

《虛實映象》系列呈現 1992 年至 2021 年的主題作品。抱持著自由自在的心態，將偶遇的奇趣美景加上多元的視角，運用光影、鏡像、反射、借景、交疊、錯位、對照等變化技巧，將「虛」與「實」相互輝映，抒發獨特的美學觀，亦表達出攝影是極其自由和充滿想像的！如「水道」（2021），平日不起眼的水道，在藝術家的眼中展現出脫俗的樣貌。水光瀲灩幻化為生動的筆觸，亦如水中綻放的睡蓮，轉化了虛與實的空間和認知概念。

此外，《虛實映象》也是繪畫性與抽象思維最為彰顯的系列。康台生創作攝影的同時長期醉心於繪畫創作，最欣賞美國畫家魏斯（Andrew Nowell Wyeth），認為其畫作中充滿故事性與抽象隱喻的表現。這也幫助康台生在面對攝影的寫實特質時，豐富了敘事性與表現力的維度。而普普藝術大師安迪沃荷（Andy Warhol）的時尚、簡練、設計感與色彩鮮明的風格亦成為其藝術攝影的養分。

誠如康台生所言：「繪畫對影像創作影響是對於空間與調性處理較為得心應手，且不會受到機械與科技限制，帶有柔軟與藝術性的氛圍。」繪畫強化了對色彩、線條和抽象造型的運用，以及對於虛與實的形式掌握。

而關於虛與實的概念，康台生認為：「拍攝作品的當下，是對場景真實的記錄，隨著時間的流逝，物換星移，當初的真實變成虛幻，成為記憶；但是作品本身的敘事性和對攝影者的意義，卻是恆久不變的。」剎那即永恆和轉瞬即逝的現象，藉由攝影特質得以映照與詮釋。「假作真時真亦假，無為有處有還無。」萬物的存在與虛無本來就是無常的，現實與想像的界限亦非絕對，皆可能藉由時空或心境的轉變而幻化。

《城市定格》系列，集結了 1996 年至 2020 年間的作品。熱愛旅遊的康台生足跡遍及世界各地。然而他反對攝影僅用來記錄旅行，認為影像是需要經過淬鍊反思的，因此作品並沒有國界的限制，甚至大部分是呈現台灣生活週遭的環境。即使是尋常的風景，只要透過多元的視角觀察與奇趣的瞬間掌握，便能發現其獨特的意涵。換言之，他所重視的並不是異國的景點，而是在某種特殊場域中，天時地利人和條件下，自然上演的人文風貌。誠如康台生所言：「城市像一座舞台，不需編導，跨越紀實與美感，作品是傳遞超越景物以外的想像。」他擅長藉由攝影的觸角來觀察和體現一個城市的生活情境與氛圍，透過豐富的色彩層次和巧妙的構圖烘托出戲劇張力與城市印象。同時傳達其內心溫暖的感受和詼諧的巧思，進而賦予更豐富的想像空間。（圖例：「危險關係」2005）

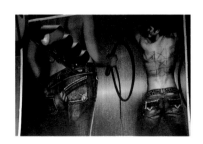

《生活符碼》系列也是康台生長期創作的主題，展覽作品年代從 1992 年至 2020 年。相較於《城市定格》系列，本系列更多著墨於自然風光與人文風景。影像的構圖與佈局也更著重於象徵元素的呈現與敘事性的營造。風格上則延續了他淡雅閒適的基調。

In the recent period, Kang's flowers are often bathed in natural light. He enjoys observing the living state of plants carefully in the natural environment and hopes to present the life cycle and natural looks in the colorful world.

The series of "Abstract and Concrete Impression" presents the thematic works from 1992 to 2021. With a free attitude, he adds the diverse perspectives to the fun and beautiful scenes of chance encounters and applies the variable techniques of light and shadow, mirroring, reflection, scene borrowing, overlapping, misplacement, and contrast so that the "abstract" and the "concrete" will add splendor to each other. He expresses his unique aesthetics that photography is full of freedom and imagination! For example, in "Waterway" (Picture: 2021), the inconspicuous waterway is represented in an unconventional way in the artist's eyes. The glittering waves depicted with the vivid strokes are like the blossoming water lilies, transforming the abstract and concrete space and cognitive concept.

Besides, "Abstract and Concrete Impression" is also a series highlighting the features of painting and abstract thinking. Kang has been dedicated to painting aside from photography for a long. He admires the American painter, Andrew Nowell Wyeth, most, believing his paintings are full of story-like expressions and abstract metaphors. This also helps Kang enrich his narrative and performance when dealing with the realistic feature of photography. The fashionable, simple, brightly-colored style of design of the master of pop art, Andy Warhol, also becomes the nutrient of his photography art.

As Kang said, "The influence of painting on image creation is the better control over the space and tone. Without the limitation of machines and technology, it has the atmosphere of softness and artistry." Painting reinforces the application of colors, lines, and abstract styles and the grasp of the abstract and concrete forms.

As for the concept of abstractness and concreteness, Kang said, "The moment of photographing is the truthful recording of the scene. With the passage of time and changes in things, the original reality turns into illusion and memory. But the narrative of the work itself and the meaning to the photographer remain unchanged permanently." The phenomenon of eternity in an hour is reflected and interpreted by means of the characteristics of photography. "Truth becomes fiction when the fiction is true; Real becomes not-real where the unreal is real." The existence and nihility of everything are ever-changing. The line between reality and imagination is not absolute but changeable with the transformation of time, space, or mind.

In the series of "Freeze Frame of City," the works from 1996 to 2020 are selected. As a travel lover, Kang has traveled all over the world. However, he is against that photography is only used to record the journey. Instead, he believes that image takes refinement and reflection. Therefore, there are no national borders among works. Most of his works present the living surroundings of Taiwan. Through the observation from the diverse perspectives and the grasp of the interesting moments, the unique meanings can be found even in the ordinary scenes. In other words, what he values is not the foreign scenic attractions but the naturally-staged cultural representation in some special field with the right time, right place, and right people. As he said, "The city is like a stage that does not take choreography. Over the actual recording and aesthetics, the works convey the imagination beyond scenes." He excels at observing and showing the life situations and atmospheres in a city through the photographic perspective and highlighting the dramatic tension and city impression through rich colors and clever composition. At the same time, he expresses his inner warm feelings and fun thoughts and further endows the works with the space for richer imagination. Picture: "Dangerous Relationship (2005)"

The series of "Life Code" is also the topic Kang has been engaged in for a long. The works range from 1992 to 2020. Compared with the series of "Freeze Frame of City," the series deals more with the natural and cultural

如「童年」（1992）作品，以海邊生長的植物為前景主體，象徵著大自然的偉大，船頭彷彿指引著人生的方向，藉由巧妙的取景，讓一群活力充沛的孩童宛如從密林間喜悅地向著未來奔跑，感覺人生蘊含著無限的可能。

康台生在教育界深耕四十多年，除了研讀國內外的攝影史觀與藝術攝影創作理論，同時也研究符號學、圖像學、敘事理論等學理，持續厚實影像創作與分析能力。

再加上對文學與電影的興趣，他發展出自己獨特的影像敘事美學。攝影元素的建構往往經過製碼與解碼的反思過程，藉由被拍攝客體各別的象徵意義以及彼此和諧或對立的互動關係，產生戲劇性的張力或耐人尋味的故事性。

康台生喜愛的敘事表現在於：「自由尋覓閱讀生活的故事。」進一步來說就是秉持著自由自在的心態，以及對萬物的好奇心與想像力，不囿限於時空環境，探索生活的感動與內心的共鳴。

時而運用抽象風格結合敘事性，時而以象徵元素來隱喻，如生命的循環，以及人與自然、環境、信仰、文化、情慾之間的關係。作品流露出猶如詩人葉慈（William Butler Yeats）的浪漫、幽玄與象徵主義風格。（圖例：「牛頭與女人」1993）

康台生的敘事表現手法蘊含著生命的哲思與生活的質感，兼具其本質的探究與人文的感受。部分作品展現出淡雅幽微的美感，或許是欣賞的日本文學家川端康成在他年少時期播下的種子，川端康成藉由寫作來探索四季山川草木與人心之美。而康台生的影像敘事「如歌的行板」，閒適流暢，蘊含著深刻的人性與禪思。

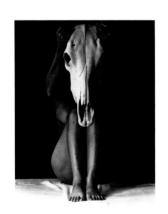

康台生認為：「攝影藝術創作的價值與意義在於撫慰心靈、提供希望、引起視覺認同與共鳴，關懷社會與見證歷史。」持續探究傳揚攝影藝術的價值是他畢生的志業。「這次展覽以誠實的態度面對自己、作品與觀眾。」心如明鏡是康台生對從心所欲年歲之境界的期許。在繪畫與攝影技巧都爐火純青之時，希冀未來將淬鍊出更自由的影像與繪畫結合的多媒材表現形式，繼續創作出自然的敘事情境。康台生豐沛的創作熱情和豐富的文藝涵養令人聯想到法國藝術家拉提格（Jacques Henri Lartigue）及其所言：「既非畫家，亦非攝影家，也不作作家，我三者皆是。（Ni peintre, niphotographe, niécrivain, je suis les trois.）」相信康台生長久的「心之所向」與多元的藝術能量將持續開拓藝術攝影的新境界。

scenes. The composition and arrangement of the images emphasize the presentation of symbolic elements and the construction of narratives more. His elegant and leisurely style is extended. For example, in "Childhood" (Picture 1992), the plants growing by the sea as the subjects in the front view symbolize the greatness of nature. The bow of the shop looks like pointing to the way of life. From the ingenious point of view, a group of energetic children looks like running to the future joyfully from the thick forest. It feels like there are infinite possibilities in life.

Kangs has been dedicated to education for more than forty years. Besides the conception of photography history and the creative theories of photography art at home and abroad, he also studies semiotics, iconology, and narrative theories and keeps strengthening the ability of image creation and analysis at the same time.

With his interest in literature and films, he develops his unique aesthetics of image narrative. The element construction of photography has to undergo the process of coding and decoding. The individual symbolic meaning of the photographed subjects and the harmonious or opposite interaction between each other will produce dramatic tension and thought-provoking stories.

The narrative expression favored by Kang lies in "freely seeking the stories that read life." In other words, it is to stick to the free mind full of curiosity and imagination for everything, unlimited to space and time, and exploring the touching moments in life and the resonance of the inner mind. He sometimes combines the abstract style with the narratives and sometimes makes metaphors with symbolic elements, such as the life cycle and the relationship between men, nature, environment, belief, culture, and desire. His works reveal the romantic, mysterious, and symbolistic style like the poet, William Butler Yeats. (Picture, "Bull Head and Woman" 1993)

Kang's narrative expression contains the philosophy of life and life texture with both the essential exploration and cultural feeling. Some works show elegant and subtle beauty. Maybe the seeds were sowed by the Japanese writer, Yasunari Kawabata, when he was young. By writing, Yasunari Kawabata explores the beauty of four seasons, landscape, plants, and the human mind. Kang's image narrative, "Andante Cantabile," is leisurely and smooth, full of deep humanity and Zen.

In Kang's opinion, "the value and meaning of photography lie in the soothing mind, giving hopes, arousing visual recognition and resonance, caring about the society, and witnessing history." It is his lifelong career to keep studying and promoting the value of photography. "Through this exhibition, I face myself, my works, and the viewers with an honest attitude." A heart as clear as a mirror is Kang's expectation at the age of seventy when one can follow his heart's desire without transgression. As his techniques of painting and photography have achieved perfection, he expects to refine the expressive style of multimedia by combining image and painting in the future and keeps creating natural narrative situations. Kang's great passion for creation and profound cultural and art self-cultivation remind me of the French artist, Jacques Henri Lartigue, and what he said: "Neither a painter, nor a photographer, nor a writer, I am all of them." (Ni peintre, niphotographe, niécrivain, je suis les trois.) I believe Kang's long heart's desire and diverse art energy will continue to expand the new horizon of the art of photography.

簡歷

康台生
Kang Tai-sen

1951 年出生於嘉義

學歷

國立台灣師範大學美術系
國立台灣師範大學美術研究所碩士

經歷

國立台灣師範大學藝術學院院長 (2000-2002)
設計研究所所長 (1998-2000)
美術系所暨設計研究所教授
輔仁大學藝術學院院長 (2010-2016)
應用美術系所教授 (2002-2017)
中華攝影藝術交流學會理事長 (2015-2019)
台北國際攝影節大會主席暨藝術總監 (2016、2018)
八方畫會會長 (2011-2013)
中華攝影藝術交流學會名譽理事長 (2019-)

專業經歷

全國美展大會委員、攝影類籌備委員暨評審委員召集人，全國公教美展、全省美展、台北市美展、高雄美展、桃源創作獎暨新北、桃園、新竹、彰化、台中、宜蘭、花蓮、嘉義、雲林、基隆、台南等縣市美展攝影類評審委員，台北市立美術館典藏委員，國立台灣美術館典藏暨展品審查委員、中正紀念堂、國父紀念館展覽審查委員、新北市美術館籌備委員、行政院新聞局金鼎獎、新一代設計獎、精品設計獎……等評審委員等。

曾任考試院高普考典試委員、命題委員，教育部藝術教育委員會委員、特教小組諮詢委員、高教司學審會分案顧問、藝術學院升格大學審查委員，大學評鑑中心規劃委員、召集人、評鑑委員，文化部公共藝術、行政院公共工程委員會專家學者等職。

展覽

曾在北京人民大學徐悲鴻藝術學院、平遙國際攝影藝術節、國立台灣師大藝廊、台北爵士藝廊、台中市立文化中心、挑園文化局、國防大學美術館、國父紀念館中山國家藝廊……等舉辦《台灣映象數位影像創作展》、《虛與實》、《花情》、《片斷》、《歐遊記行》、《敘事台灣》、《浮世百敘》薪傳展、《敘事：真實‧記憶》、《淬鍊‧省思》……等十七次攝影個展，應邀全國美展、全省美展、台灣各縣市美展、桃園市暨新北市美術家邀請展、師大、輔大教授聯展、兩岸三地攝影家聯展、平遙、大理、北京、台北國際攝影節、Photo Taipei、FAS 藝術博覽會、法國巴黎 Impressions Galerie Librairie 和 Galerie Villa Des Arts 藝廊……等展出。

策展

曾擔任澳洲昆士蘭科技大學、中國廈門大學交流展，中國平遙國際攝影節，兩岸三地攝影名家邀請展，台北國際攝影節，師大 SOLO 藝術特區，師大捷運藝術節等大型活動暨展覽策展人。

著作

出版廣告攝影構圖研究、風景攝影類型研究、攝影學……等專書，以及在學報、期刊、國際研討會等發表論文三十餘篇。

Educational Background

BA, Department of Fine Arts, National Taiwan Normal University

MA, Department of Fine Arts, National Taiwan Normal University

Experience

Dean of the College of Arts, NTNU (2000-2002), Director of the Graduate School of Design (1998-2000), Professor of the Department of Fine Arts and the Graduate School of Design

Dean of the College of Art, Fu Jen Catholic University (2010-2016), Professor of Department of Applied Arts (2002-2017)

Chairman of the Chinese Society of Photographic Art Exchange (2015-2019)

President and Art Director of TAIPEI PHOTO (2016, 2018)

Director of Ba Fang Art Association (2011-2013)

Honorary Chairman of the Chinese Society of Photographic Art Exchange (2019-)

Professional Experience

Committee member, preparation committee member and convener of the photography jury of National Fine Arts Exhibition, photography jury member of National Civil Officers Art Exhibition, Provincial Fine Arts Exhibition, Taipei City Art Exhibition, Kaohsiung Art Exhibition, Taoyuan Contemporary Art Award, and the county and city art exhibitions including New Taipei City, Taoyuan, Hsinchu, Changhua, Taichung, Yilan, Hualien, Chiayi, Yunlin, Keelung, and Tainan, collection committee member of Taipei Fine Arts Museum, collection and exhibition review committee member of National Taiwan Museum of Fine Arts, exhibition review committee member of National Chiang Kai-shek Memorial Hall and National Dr. Sun Yat-sen Memorial Hall, preparation committee member of New Taipei City Art Museum, jury member of the Golden Tripod Awards of Government Information Office, Executive Yuan, Young Pin Design Award, and Taiwan Excellence Award.

Former examiner and drafter of the Civil Service Examination, Examination Yuan, art education committee member and advisory committee member of the special education group of the Ministry of Education, case consultant of the academic review committee of the Department of Higher Education, evaluation committee member of the college of arts promotion to university, planning committee member, convener, and evaluation committee member of Center for College Evaluation, expert and scholar of public arts of Ministry of Culture and Public Construction Commission, Executive Yuan

Exhibitions

Held 17 photography exhibitions including "Taiwan Image: Digital Image Creation Exhibition," "Abstractness and Concreteness," "Flower Love," "Fragments," "Trip to Europe," "Depict Taiwan," "Hundred Perspectives of the World," "Narration: Truth, Memory," and "Refinement, Reflection" at Xubeihong School of Arts of Remin University of China, Pingyao International Photography Festival, National Taiwan Normal University Art Gallery, Jazz Image Taipei, Taichung City Cultural Center, Department of Cultural Affairs, Taoyuan, Art Museum of National Defense University, and Chungshan National Gallery of National Dr. Sun Yat-sen Memorial Hall. Invited to exhibit works at National Fine Arts Exhibition, Provincial Fine Arts Exhibition, the county and city art exhibitions in Taiwan, Taoyuan City and New Taipei City Artists Invitation Exhibition, Joint Exhibition of the Professors from NTNU and FJU, Cross-Strait Photographers Joint Exhibition, Pingyao International Photography Festival, Dali International Photography Exhibition, Beijing Photography Festival, Taipei Photography Festival, Photo Taipei, Formosa Art Show (FAS), and the galleries in France, Impressions Galerie Librairie and Galerie Villa Des Arts.

Experience in Curating

Served as the curator of the large events and exhibitions at Queensland University of Technology, Exchange Exhibition with Xiamen University, Pingyao International Photography Festival, Cross-strait Famous Photographers Invitation Exhibition, Taipei International Photography Festival, NTNU SOLO Art Zone, and NTNU MRT Art Festival.

Publications

Published the research books on advertising photography composition, landscape photography types, and photography and over 30 essays in journals, periodicals, and international conferences.

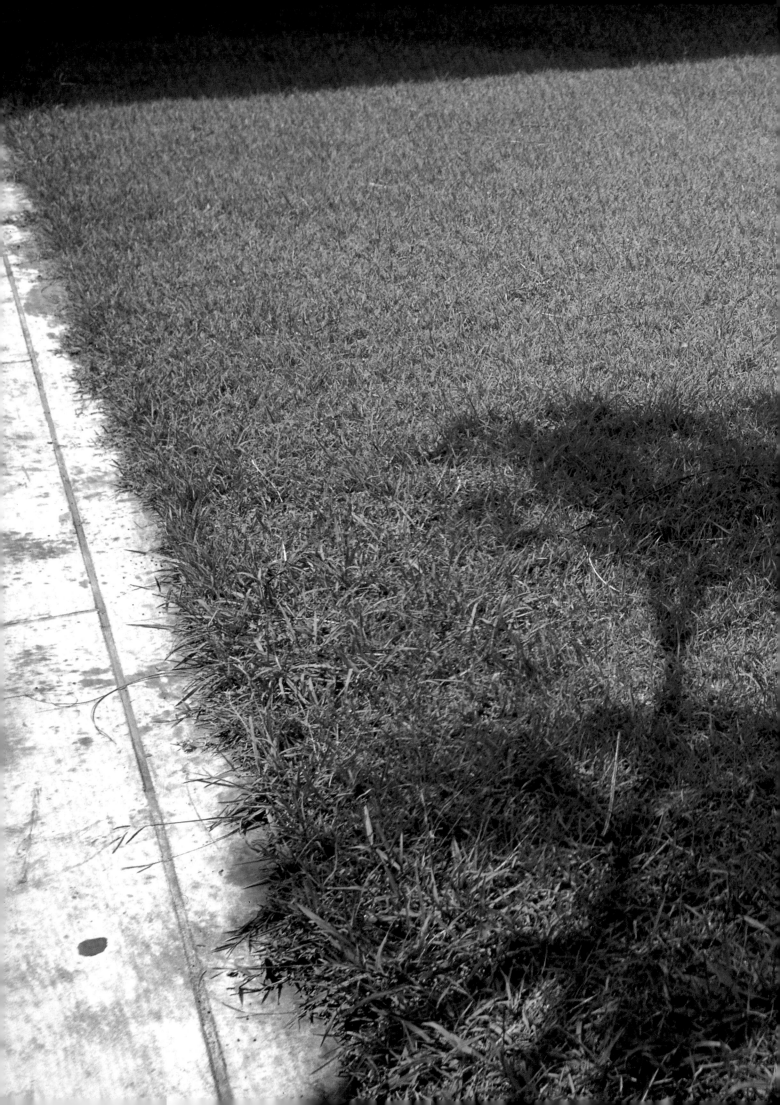

Refinement
& Reflection

淬鍊　　　省思

康台生敍事影像

藝術家 康台生

發行人 王蘭生　總編輯 楊同慧

出版者 國立國父紀念館
National Dr. Sun Yat-sen Memorial Hall

執行編輯 楊得聖、何友齡　　執行總策畫 鄧博仁

美術設計 李煜函　　展場設計 陳玉書　　英文校對 任季如

製版印刷 佳信印刷　　ISBN 978-986-532-604-3　　GPN 1011100844

售價 1000 元　　出版日期 2022 年 8 月

Author Kang Tai-sen

Publisher Wang Lan-sheng　　Chief Editor Yang Tong-hui

Distributor 國立國父紀念館
National Dr. Sun Yat-sen Memorial Hall

Executive Editor Yang De-sheng, Ho Yo-ling　　Chief Planning Teng Po-jen

Art Designer Li Yu-han　　Exihibition Designer Chen Yu-shu　　English proofreading Clair Jen

Printing Company Chia Hsin Printing CO., LTD.　　ISBN 978-986-532-604-3　　GPN 1011100844

Selling Price NT$1000　　First Published in Taiwan in 2022.8

國家圖書館出版品預行編目（CIP）資料

淬鍊 省思：康台生敘事影像＝Refinement & reflection/

康台生[作]. -- [臺北市]：國立國父紀念館, 2022.08

144 面 ; 29*22 公分 ISBN 978-986-532-604-3(精裝)

1.CST: 攝影集 958.33 111009736